Elfrieda

CRASH COURSE IN
ART

CRASH COURSE IN
ART

EVA HOWARTH

CAXTON EDITIONS

British Library Cataloguing in Publication Data
Crash course in art.
 1. Western visual arts, history
 1. Howarth, Eva
 709

Designed by Tim Scott
Typeset by Spectrum Typesetting Ltd, London
Origination by Columbia Offset Ltd
Printed and bound in Singapore

This edition published 2001 by Caxton Editions
an imprint of The Caxton Publishing Group

Reprinted 2003

ISBN: 1 84067 1629

FRONTISPIECE: DE VLAMINCK *Paysage au Bois Mort (detail)*

FACING PAGE *(top):* MARTINI *Christ discovered in the Temple*

FACING PAGE *(bottom):* FABRIANO *The Presentation in the
Temple*

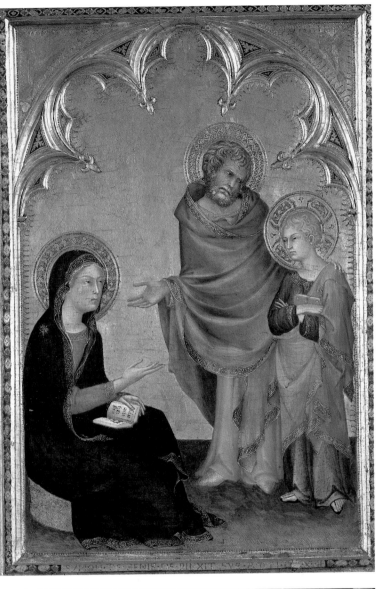

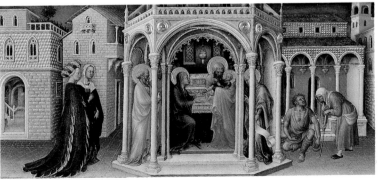

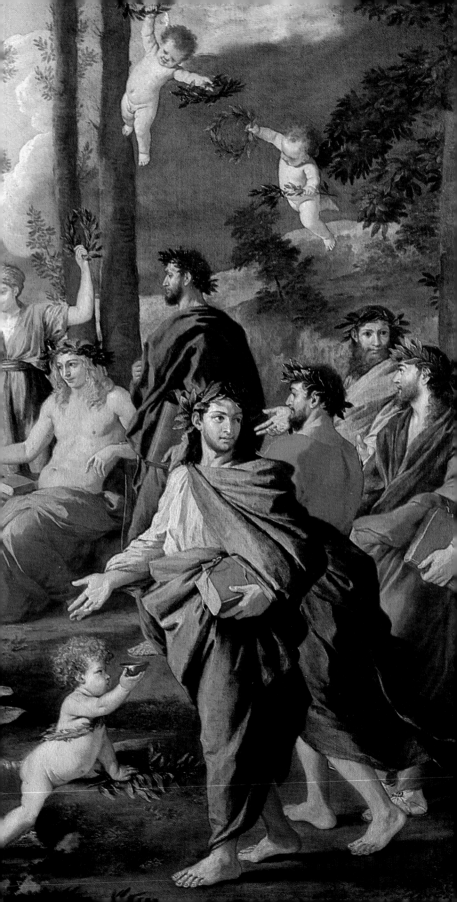

Contents

FACING PAGE: POUSSIN *Parnassus* (detail)
OVERLEAF: ROSSETTI *Proserpine* (detail)

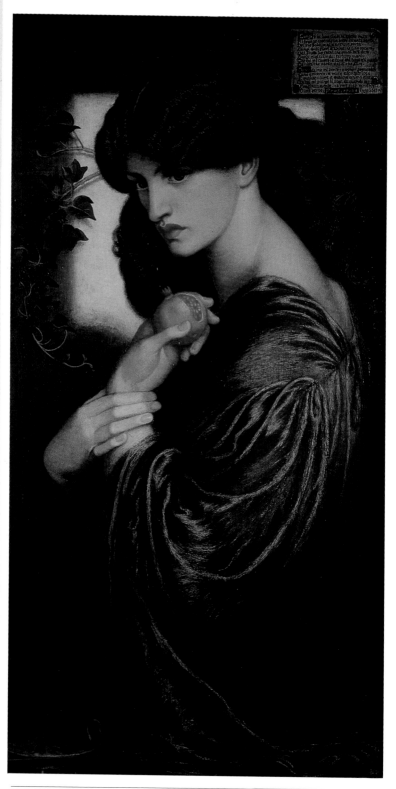

INTRODUCTION

This is a book to be taken with you whenever you have a chance to look at paintings – for example, when you are visiting art galleries, museums and churches.

The book has been designed so that you can discover, while you are still in front of a particular painting, the information you need to gain a fuller appreciation and understanding of it.

You will find this is true if you are one of the many who enjoy paintings, but have no expert knowledge. You will also find it to be true if you are much more than averagely well informed, for a great deal of expertise is concealed by the disarmingly simple way in which, in this short book, the art of centuries is presented.

You can of course read the book from cover to cover – but it is as a ready guide of a kind not produced before, bringing to countless people a new depth of pleasure, that the book will serve its main purpose.

A unique feature of the book is its Compendium of Artists (see page 150) and the way you can put this to practical use.

All you need to know is the name of the artist of any work you happen to be interested in. The book will lead you on from there, giving you just the sort of help you might receive if you had with you an expert on painting who could explain things clearly.

Chronology

THE MEDIEVAL PERIOD

13th-14th Century

In the early Christian church opinions were divided about whether the human form should be portrayed in art. It was generally agreed that statues were undesirable. They suggested the graven images against which Old Testament prophets had thundered so forcefully.

Paintings, however, were different. In the sixth century Pope Gregory declared that they were a most useful way of telling Bible stories, particularly to people who could neither read nor write. This judgement was to have a profound influence on the development of European art from the early Middle Ages onwards.

In the medieval paintings which have survived the themes are virtually all religious, and the purpose is clearly didactic. A high proportion of these paintings are Italian, and the influence of Byzantium is strong in nearly all of them.

This was a direct consequence of the shift of power in the Roman Empire eastwards from Rome to Byzantium. In the late third century the Emperor Diocletian divided the Empire into an eastern and a western part in the hope that this would make it both easier to rule and to defend against the barbarians. In the next century Constantine reunited the Empire, but it was Byzantium, then renamed Constantinople, which he made its capital.

This unity could not be maintained, but the eastern Empire continued to flourish for centuries after Alaric the Goth sacked Rome early in the fifth century. Italian cities, Venice in particular, carried on trading with Byzantium, from where art treasures were sometimes brought back by the shipload.

A major art form in Byzantium was the **mosaic,** and this strongly influenced medieval painters in Italy.

Some of the Byzantine mosaics which have survived are clearly masterpieces and indicate the very high level of artistic achievement of the period.

The subjects were either religious or scenes from Byzantine court life. The treatment was formal.

Figures were two-dimensional, and the background was usually a rich gold. The people portrayed nearly always looked straight ahead, and there was little variety of expression. They had large rounded eyes, strong brows and small chins. Garments were heavily draped, and the shape of the body was not revealed. The 13th-century Italian painting opposite shows strong Byzantine influence.

The picture is two-dimensional. The figures look as if they have been cut out of cardboard and slotted one above the other. The angels are all looking straight ahead and not at the central characters or at each other. The background is solid gold.

Yet in some important respects the painting differs from Byzantine works of art. There is real emotion in the softly smiling faces of the Madonna and the angels.

There is also a symmetry both in composition and colour, which is characteristic

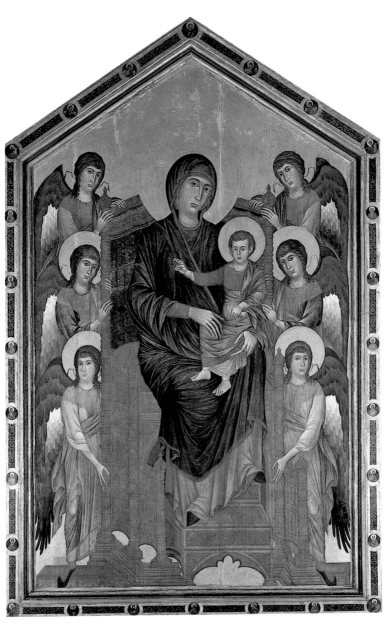

CIMABUE *The Virgin and Christ in majesty surrounded*

of the art of the period. All the angels on the left side have their counterpart on the right side of the Madonna. There is a similar symmetry in the juxtaposition of the colours.

THE TRUE BEGINNING
OF WESTERN PAINTING

ITALY

A sudden and dramatic break with Byzantine tradition took place in 14th-century Italy. Paintings became realistic and life-like, and the influence of the new style was so far-reaching that many art historians regard it as the true beginning of Western painting.

Three important styles emerged. The first two were centred on Florence and Sienna. The third was known as the International style. Each of these styles had its own strong characteristics, but they had some important features in common.

GIOTTO *Madonna in glory*

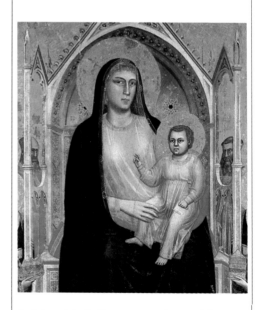

Artists painted either on wood or straight on to a wall, in a technique known as **fresco**. The pigment was laid on to damp plaster so that when the plaster dried out the colour was an integral part of the wall and did not flake off.

The colours appear soft, while those used on panel paintings were much deeper and richer.

The two most important colours were blue and gold. Both of these were very expensive so, when an artist was commissioned to do a painting, his contract would state the amount of gold and blue he was to use. The amount stipulated would indicate the status of the patron.

Blue pigment was obtained by grinding up lapis lazuli, a semi-precious stone, which had to be imported from the east. It was reserved for the most important figures in the painting; the Madonna's gown was the richest blue, while the lesser figures such as angels would have gowns of lighter blue, which required less of the costly pigment.

The gold was made of fine gold leaf and applied over a red-coloured clay to give it extra richness.

Polished gold, frequently punched with a pattern to give it an even richer appearance, was often used mainly on decorative features.

MARTINI *Christ discovered in the Temple* (details) *Virgin* (above) *Joseph with Christ* (below)

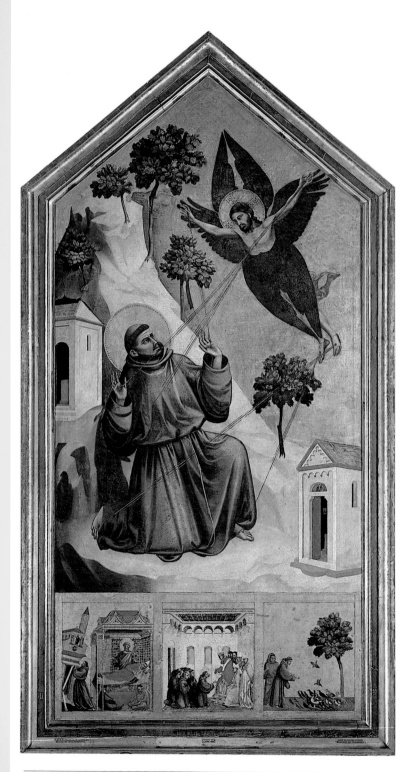

It was also used for haloes, which helped to identify holy figures.

The main reason why the artists used so much gold, and particularly polished gold was that it reflects light and therefore made the paintings more easily seen in the dark churches.

The pictures were painted in the knowledge that they would be seen in the glow of candlelight, and it is questionable whether even the best of modern lighting can re-create the original effect.

In some paintings of this period a rather disturbing greenish tint can be seen, particularly in the faces. The explanation for this is that the original colour was worn off in places, and what is seen is the underpaint.

The paintings often tell stories taken from the Bible. At a time when only the rich possessed handwritten books and few lay people could read, pictures and sermons were the most effective ways of teaching the Bible.

To tell his story convincingly the artist would use techniques which may seem strange today.

In some pictures, while the main action of the story is depicted in the foreground, incidents which took place much earlier on are shown in the background. For example, the theme of a picture may be the three kings worshipping Christ. In the background we can see the kings setting out on their journey.

The sizes of the figures and other objects are decided not by their distance from each other but by their relative importance in the story.

Gold as a background is gradually replaced by a landscape or an architectural setting. Most of the backgrounds are rather like stage sets. Sometimes they have only bare essentials: for example, the outlines of a few trees to indicate the countryside or some houses to indicate a town.

In other paintings the setting is more elaborate, with architectural features framing the figures. The style of the architecture is usually either Italian Gothic or classical.

With the help of these techniques we see all that the artist intended us to see, and we

CIMABUE *The Virgin and Christ in majesty surrounded* (detail)

GIOTTO *St Francis receiving the stigmata* (opposite)

understand the story he is telling us in much greater detail.

Florence

In contrast with the two-dimensional form of presentation in earlier paintings, the figures are all realistic.

These are real people, with rather heavy bodies, broad shoulders and wide hips. The faces are much broader and the jaw line more pronounced. Particularly characteristic of the period are the almond-shaped eyes.

The garments fall in heavy V-shaped folds and clearly indicate the figure underneath.

Earlier painters used dark lines to indicate the folds of the garments. The much more realistic look here is achieved by subtle shading.

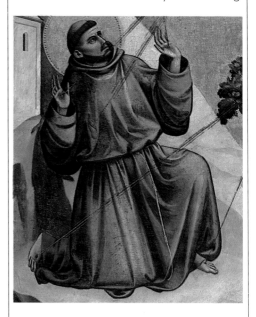

GIOTTO *St Francis receiving the stigmata* (detail)

Colours are soft and natural. Gold is used only for the haloes of the saints.

Characteristically for paintings of this period, there is an even light throughout the picture and there are no shadows.

For the first time Christ and the Madonna are shown as human beings with human emotions.

The pain of Christ is evident. The sorrow of the Madonna is like the sorrow of other mothers. Emotion is registered both in the faces and in the expressive gestures.

Sienna

In Siennese art the change towards realism was much more gradual than in that of Florence.
For some time, painters tried to combine the Byzantine tradition with a degree of reality.

DUCCIO DI BUONINSEGNA
Madonna and Child (detail)

The Madonna and Child are looking at each other instead of straight ahead. The hand of the Child holding the veil and the drapery of the rich blue gown have an evident realism.
Under Florentine influence the paintings became much more natural but retain a style of their own.

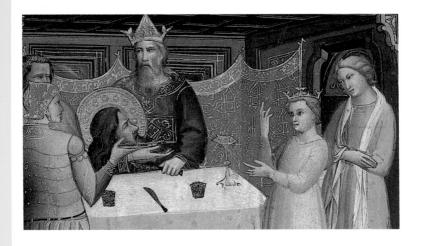

LORENZO *Herod's Banquet*
(detail)

The faces became more angular and the eyes are more slanted. The tone of the skin is more natural. Many of the women have fair hair, and even some of the Madonnas are blonde.

Siennese paintings are generally very elaborate. Costumes, architectural features and floors tend to be richly decorated. Chequered or plaid patterns on cloaks and covers are characteristic features.

The subjects of a number of paintings are secular and some of them give a fascinating representation of everyday life in the 14th century.

MARTINI *The Annunciation*
(detail)

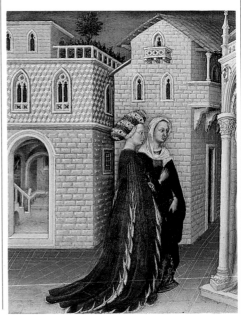

FABRIANO *The Presentation in the Temple* (detail)

THE INTERNATIONAL STYLE

During most of the 14th century the residence of the Popes was not in Italy, but in Avignon, France. Painters from all over Europe came to the papal court, thus gaining the opportunity to study the work of artists from other schools.

In France, much of the best painting was being done in miniatures and in illuminated manuscripts.

POL DE LIMBOURG *The Meeting of the Magi from the Hours of the Duc de Berry*

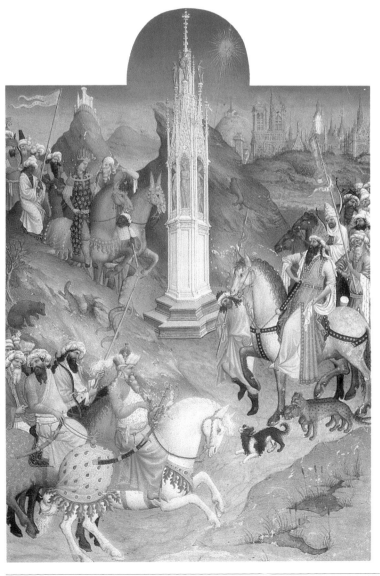

Most of the manuscripts were produced by and for the clergy. In addition to these, a new kind of manuscript, called *The Book of Hours*, made its appearance. This was for rich patrons who wanted to follow the liturgy in their own private chapels.

The painters decorated the pages with animals, birds, plants and little vignettes from everyday life which they reproduced with great accuracy.

The International Style, as it came to be known, was largely a fusion of French and Siennese artistic styles. It spread widely through Europe, became popular in a number of European courts and attracted some very rich patrons.

The artists working in this style used expensive pigments. The paintings give an immediate impression of being precious objects with a glittering, jewel-like quality.

The concept of beauty has changed; women's faces are oval and the features are small and refined. Cheeks are painted in pale pink, and the forehead and brows are highlighted in white. The hair is often blonde, and the final effect is not unlike a golden doll. The figures are slim and elongated and the fingers long and slender.

FABRIANO *Adoration of the Magi* (detail)

Men's faces are also elongated and are often dark and angular, with high cheekbones and slightly almond-shaped eyes.

Much attention is paid to drapery, and folds fall in beautiful, undulating curves.

Some of the materials, particularly those worn by kings and queens, are extraordinarily rich and heavily embroidered.

One of the characteristic features is the attention paid to animal life. Horses, dogs, birds and monkeys, which were often kept as pets in wealthy households, are all realistically portrayed.

Flowers and fruit are painted with the same precision and delicacy.

Much closer attention is paid to details of landscapes than in earlier paintings, although

the settings are still not quite realistic and the impression of a stage set persists.

Looking at some of the pictures in this style is rather like taking part in an unusually spectacular pageant.

GOZZOLI *Journey of the Magi to Bethlehem* (detail)

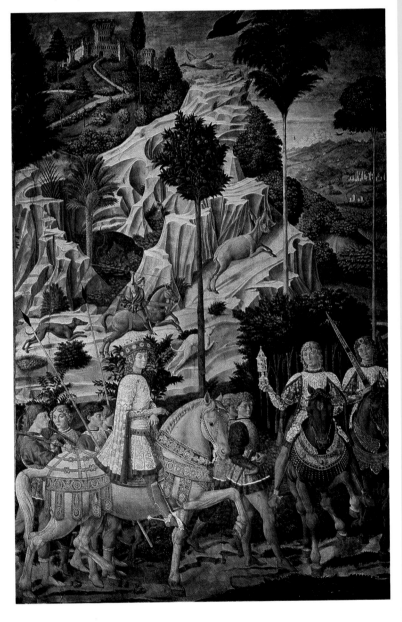

Chronology

1431 Joan of Arc burnt at Rouen

1437 Henry the Navigator founds the Colonial and Naval Institute at Sagres in Portugal

1448 Fra Angelico paints Vatican frescoes

1450 The Vatican library is begun

1453 Fall of Constantinople

1454 Gutenberg sets up a printing press in Mainz

1461 Villon writes *Le Grand Testament*

1469 Lorenzo de' Medici the Magnificent becomes ruler of Florence

1479 The union of Aragon and Castile

1492 Columbus discovers the West Indies

1493 Pope Alexander III divides the New World between Spain and Portugal

1498 Vasco da Gama reaches India

1508 Michelangelo begins painting the ceiling of the Sistine Chapel

1512 Copernicus declares the earth revolves round the sun

THE RENAISSANCE

15th Century

The great intellectual and spiritual awakening known as the Renaissance – or rebirth – began in Italy. To a large extent it was a consequence of new discoveries of the thought and art of classical Greece and Rome.

Renaissance artists all looked to classical Rome for guidance and inspiration. Architects and sculptors could study the ruins of buildings and sculpted figures. Painters had a much more difficult task.

In the 15th century there were only a few fragments of mural paintings which were known to have survived. (Our present-day knowledge is based on paintings which were found at least 200 years later.) The artists of the 15th century had therefore to rely on classical literature for their understanding of these paintings.

For example, from a story told by the Roman historian Pliny the Younger they learnt about an artist who painted a bowl of fruit so realistically that a bird flew down to the painting and tried to eat the fruit.

Renaissance painters aimed to achieve the same degree of reality in their own paintings.

THE RENAISSANCE IN ITALY

A major breakthrough was the discovery of the mathematical laws of **linear perspective** which made such paintings possible.

By applying these laws artists were able to achieve a convincing illusion of three-dimensional space on a flat surface. From a fixed viewpoint all the parallel lines receding into the distance would appear to converge at

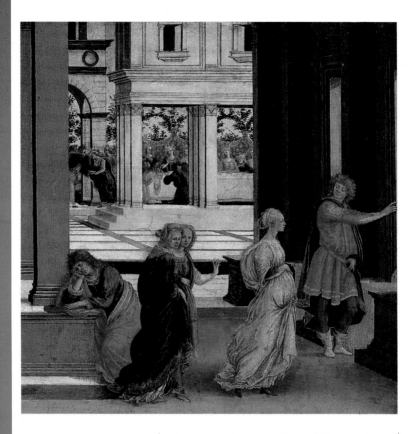

LIPPI *Esther and Ahasuerus*
(detail)

a single point, known as the vanishing point, on the horizon.

Artists could therefore draw up a grid which enabled them to place figures and objects in their correct relationship in space to each other and to the viewer. Figures and objects in the foreground appeared larger, and those in the background smaller. The picture frame became a window through which the viewer was invited to explore the space beyond.

FLORENCE

This discovery of linear perspective was one of the most significant events in the history of European art. Florentine artists were the first to master the technique, but its use soon spread throughout Italy, and by the second half of the 15th century it reached northern Europe.

Florentine painters of the period also studied anatomy scientifically and, for the first time, started to draw from life. Their interest in the human body was such that at a later date some artists actually dissected corpses, although this was an illegal practice for which the penalties were severe.

In Renaissance pictures light originates from one source only and, in its passage, illuminates figures and their setting equally. In this they differ from earlier paintings, in which light was concentrated mainly on the central figures.

Shadows make their first appearance. The fact that all the light comes from one direction only is emphasized by the way in which all the shadows are thrown in the same direction.

Figures are clearly defined by outlines in darker tones.

Antique sculpture provided the prototype for the ideal human or divine figure. For example, Christ is presented as a physically perfect being. St Peter is portrayed as an older man, but fit and strong rather than bent or withered by age.

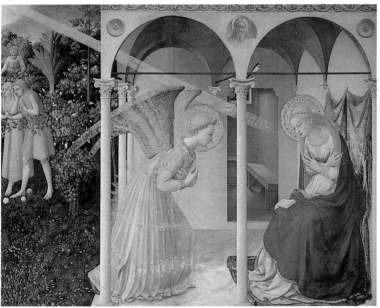

ANGELICO *The Annunciation* (detail above)

Carefully balanced compositions are a characteristic feature of Renaissance painting.

27

For example, figures are often placed symmetrically around a central personage or some other focal point.

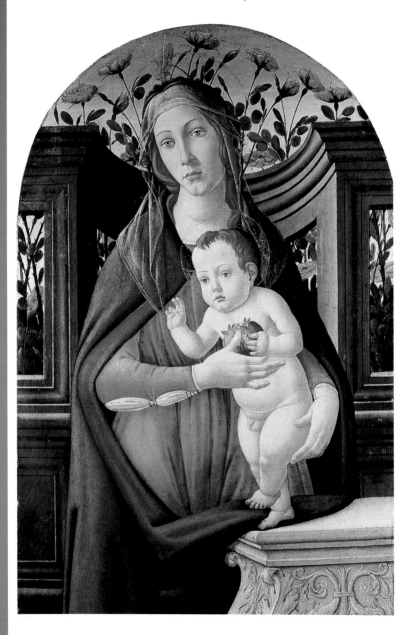

BOTTICELLI *The Madonna and Child in a niche decorated with roses*

Women are painted in a slightly elongated manner, with blonde hair and dreamy expressions.

The principal subjects continued to be religious ones.

Mythology

In the late 15th century mythology became a popular subject for paintings, and its themes were accorded the same status as religious ones. Some painters even gave them a Christian interpretation.

Painting mythological subjects gave artists an opportunity to depict nude figures, both male and female, outside a religious context. For example, instead of painting Adam and Eve, the artist could paint Venus and Mars and be justified in emphasizing the sensual character of the nudes.

BOTTICELLI *The Birth of Venus*

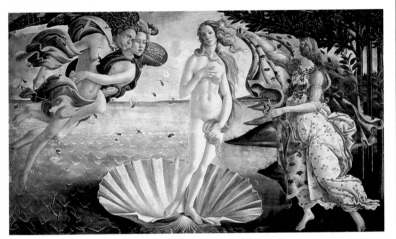

Florentine painters used mainly egg tempera for their panel paintings. Towards the end of the century painting with oil became more common. Sometimes both oil and tempera were used in the same picture.

Frescoes

In 15th-century Florence the tradition of painting fresco cycles for churches continued, but the artists approached their task in new ways.

Applying the laws of perspective, artists painted buildings which were so realistic that

they gave the illusion of being part of the church itself. The dramatic action in the painting seemed to be spilling over into the real building.

MANTEGNA *Detail from the ceiling of the Camera degli Sposi, Palazzo Ducale, Mantua* (fresco)

The subjects chosen for these paintings were usually lively and dramatic, and biblical events were frequently shown in contemporary settings.

GHIRLANDAIO *The Last Supper* (detail)

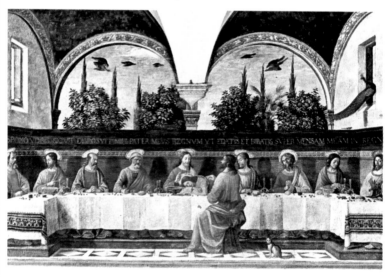

In many of these frescoes portraits of eminent citizens were included in the crowd scenes, often as witnesses to a miracle or some other important event.

The bulk of the picture was usually painted in true fresco, with the elaborate details added after the plaster had dried.

Portraits

Portrait painting became widely popular in Florence and elsewhere in Europe in the 15th century.

The Italian artists studied Roman coins and medals. This influenced the style of early portraits so that only the head and shoulder were shown and the portrait was in profile.

As it is difficult to flatter the subject and disguise prominent features in profile, such portraits were considered the truest representation of the individual.

True likenesses for men were considered important, while women tended to be flattered in ways that the fashion of the time indicated. High foreheads, long noses, small chins, fine eyes and blonde hair in elaborate styles were much admired.

From the second part of the century, Italian artists began to paint portraits in three-quarter profile, often with a landscape as a background.

VENICE AND NORTHERN ITALY

Most 14th and early 15th-century Venetian painters worked in the Gothic style. Gold

DELLA FRANCESCA *Federigo da Montefeltro, Duke of Urbino*

SCHOOL OF VENETO *The Visitation*

backgrounds, rich frames and dark-eyed, stiff-backed Madonnas surrounded by saints were characteristic features of their paintings.

Venice was not the only important art centre in northern Italy, and there was for this reason considerable variety, as well as richness, in the work of the region.

Two very different styles of painting emerged. The first is an essentially linear style, in which contours are emphasized, figures are angular, and lines meet at angles rather than curves. In paintings of nudes one is more aware of the bone structure than of the flesh. Cold colours and a clear cold light dominate the pictures. Even the backgrounds tend to be rocky and hard.

CRIVELLI *The Annunciation* (detail)

In complete contrast, the second style is much more natural, with soft, rounded lines. The background, which is often the Venetian countryside, is also more mellow and tends to be very detailed.

Painters were interested in the way light changes during the day and also from season to season. The same landscape might be painted first in a clear morning light, then under the bright midday sun, and finally in the warm light of an autumn day.

Exceptionally accurate copies of Roman buildings and landmarks such as Trajan's column, the Colosseum, the Pantheon or the statue of Marcus Aurelius are curious features of some of the paintings.

THE RENAISSANCE IN NORTHERN EUROPE

THE NETHERLANDS

In the 15th century the most important centres of art in northern Europe were in the Netherlands.

Like their Italian contemporaries, Flemish painters were concerned with the problems of painting in a realistic manner.

From about the middle of the 15th century onwards they also made use of the formula for linear perspective.

Oil paint, which originated in the Netherlands, was widely used. This too was a development of the greatest importance.

Oil used as a binder for pigments was not a new discovery; the novelty lay in its application. When you look at the oil paintings of this period you are not aware of the brushstrokes. The reason for this is that the paint is applied in thin glazes. This gives a rich, glowing colour and a jewel-like quality to the painting.

Oil paint used in this way enables the artist to capture the modelling of a face or form or the quality of a material with subtlety. The transition from a light area to a dark one, which is needed to create the illusion of three dimensions in the fold of a cloth or in the shadow under a face, can be gradual.

Oil dries slowly, and errors can therefore be corrected. In some paintings, because the oil has become transparent with age, these corrections can now be seen. They are known as **pentimenti**.

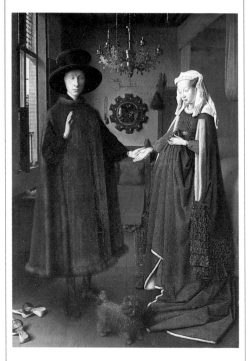

EYCK *The Arnolfini marriage*

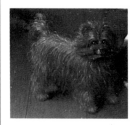

Attention to detail was of the greatest importance. The coat of a dog is carefully painted with a fine brush, hair by hair. Every stitch in an embroidered coat or the grain in floorboards and beams is faithfully recorded.

This tradition has its roots in medieval manuscript illumination, where human figures, animals, flowers and all other objects were lovingly portrayed in minute detail.

Religious paintings

The most important Dutch paintings of the period were religious ones, the larger paintings being for the churches and smaller ones for private homes.

The paintings intended for private homes give a very accurate reflection of contemporary life. Even the Virgin Mary is often shown in a setting which could have been in the house of any of the rich merchants.

Northern artists tended to omit haloes but would use some other means to draw attention to the Virgin's head, for example by placing her against an elaborately embroidered curtain.

Often one or two windows are included in the picture. This gave the painter a chance to show in detail part of the townscape or

EYCK *The Rolin Madonna* (detail)

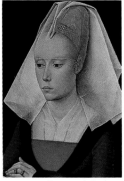

WEYDEN *Portrait of a Lady*

EYCK *Eve, from the Ghent altarpiece*

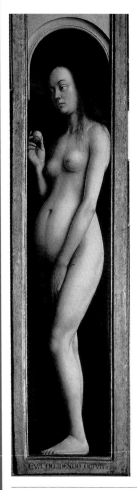

landscape. Towns reflect contemporary domestic architecture, with a cathedral or church dominating the skyline. Scenes such as men climbing ladders or a discussion taking place in the street, or even men fishing in a river, can be seen through the windows.

Landscapes, which by themselves were not considered a proper subject for a picture, were used only as a background, though painted in a realistic manner.

Vivid green was often used in the foreground and a mellow golden brown in the middle distance. The part nearest to the horizon was usually painted blue. This colour combination helped to create an illusion of depth.

The medieval tradition of identifying characters by the objects they hold, as well as the clothes they wear, is continued. A further development of this is called **disguised symbolism**, in which everyday objects take on a new meaning. For example a white hand towel and a glass bottle would be read as symbols of the Virgin's purity. A dog is a symbol of fidelity.

Portraits

In the Netherlands, portraits were painted in three-quarter profile and half length. The sitter would often hold an object which had some reference to his or her status. Alternatively, the object would appear to rest on the picture frame to create a greater sense of reality. Much care was taken to ensure that details were correct.

In northern Europe, the artists' ideals of feminine beauty differed from those of the Italian painters. Small breasts and swollen stomachs were admired and the facial features which appealed to contemporary taste were heavily lidded eyes, long thin noses, and small mouths with full lips. Their hair was usually hidden under veils or headdresses. Men's faces were painted with greater variety and realism, even wrinkles and warts being included.

EYCK *The Rolin Madonna*
(detail)

Donor portraits

In donor portraits the patron and sometimes his family are included in the painting. They are often portrayed as attending a particular religious event or being presented by their patron saints to holy figures.

In some pictures the patrons were depicted as the same size as the holy figures; in others they were shown on a much smaller scale. The effect is rather strange, but the practice was thought to indicate the humility of the donor.

GERMANY

Fifteenth-century German artists were conservative and inclined to resist change. For example, gold backgrounds were used until the end of the century, long after they were abandoned in other European countries. The majority of the paintings indicate great piety and emotional intensity.

German artists were regarded simply as craftsmen and, as such, had a lower social standing than their counterparts in Italy. This helps to explain why many German artists remain anonymous. Some are referred to by nicknames, and we often come across the statement that the work was by 'the Master of....'

One of the main centres of German art was Cologne, where artists maintained the German Gothic tradition and painted charming small figures against gold backgrounds. Some painted the human body in a particularly soft and hazy way. The figures in the paintings are usually seen in lavish contemporary dress.

The Cologne school is also well known for the number of paintings depicting the Adoration of the Three Kings. This may be due to the fact that Charlemagne came to the town after his coronation and relics of the three kings were reputed to be in Cologne Cathedral. At

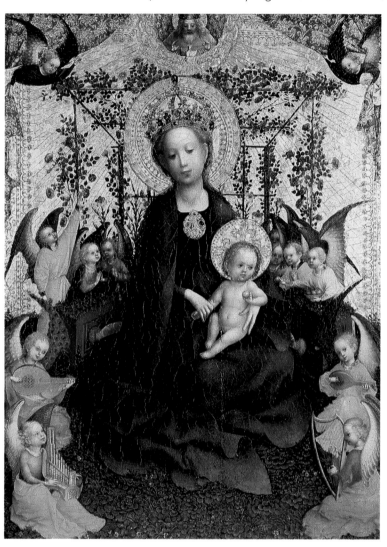

LOCHNER *The Virgin in a rose arbour*

There are two main styles of 15th-century German painting. In one there is a serene quality with rich, strong colours. The women have calm and sweet expressions while the men look rather serious and reflective. The figures seem to stand on tiptoe or even to float. The impression is of something almost other-worldly. This is in direct contrast to contemporary paintings in other parts of Europe, where biblical scenes are shown in a much more realistic manner.

The other style is much more intense and emotionally overcharged. Scenes of pain and sorrow are highly dramatized, the figures having contorted faces and distorted limbs. The scenes are often so crowded that the effect is almost claustrophobic, and it is difficult to distinguish between the intermingled figures.

Prints

Prints became very popular during this period, largely because they were cheaper than paintings.

Some of them were extraordinarily complex and particularly well suited to the German linear tradition.

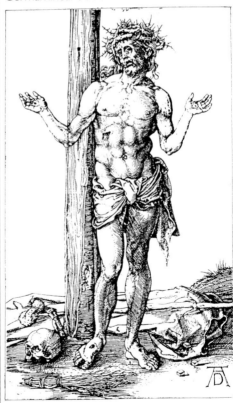

DÜRER *Man of Sorrows with hands raised*

Chronology

THE HIGH RENAISSANCE

16th Century

Through the work of a number of painters who lived in small Italian city-states in the 16th century Western culture has become permanently enriched.

The most important artistic centre was Florence, where members of the ruling Medici family combined political and commercial skills with artistic patronage in a unique manner.

The Medicis' ascendancy was established in the 15th century. Towards the end of his life Cosimo de' Medici made a practice of walking through Florence, which he had done so much to embellish, with his eyes closed. When asked by his wife why he did so, he replied that he wanted to become used to not being able to see the things he loved.

This kind of patronage caused major artists to be regarded as important and influential individuals, enjoying a much higher social status than their predecessors. It also gave them a

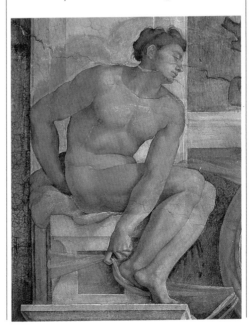

MICHELANGELO *The Sistine chapel ceiling, Ignudo* (detail)

new authority in determining how their work should develop, and they sometimes even overruled their patrons.

During the 16th century Rome also was a magnet for painters. Pope Julius II, in the early years of the century, and the Popes who succeeded him were exceptionally discriminating patrons of the arts. The work they commissioned included large fresco cycles with religious themes, individual altarpieces, portraits and mythological subjects.

The two principal styles of 16th-century painting in Europe are generally known as **High Renaissance** and **Mannerism**.

HIGH RENAISSANCE

ITALY

The main characteristics of High Renaissance painting are harmony and balance in construction, a very high level of technical competence, and rich artistic imagination.

MICHELANGELO *Expulsion of Adam and Eve*

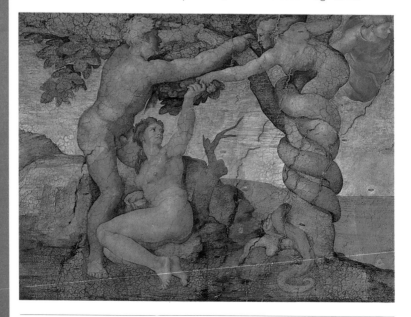

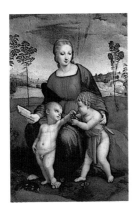

RAPHAEL *Our Lady of the Goldfinch*

High Renaissance artists achieved new classical standards comparable with, or even surpassing, the works of ancient Greece or Rome. Forms, colours and proportions, light and shade effects, spatial harmony, composition, perspective, anatomy – all are handled with total control and a level of accomplishment for which there are no real precedents.

The human figure in paintings reached a peak of idealization both anatomically and aesthetically and tends to dominate High Renaissance painting. At first it is seen in relatively static poses. Later on, bodies are shown twisting and turning in elaborate movement.

Contrapposto was a popular technique. In this the lower parts of the body, the hips and legs, may point in one direction, while the shoulders and chest are twisted to face the other way.

Certain artists adopted a manner of painting which called special attention to light and shade effects. This was known as **chiaroscuro**, an Italian word meaning light and dark.

In chiaroscuro painting figures seem to emerge from total darkness through gradually

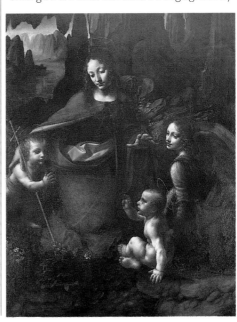

LEONARDO DA VINCI *Virgin of the rocks*

43

decreasing shadows towards the light.

The use of chiaroscuro can create drama and movement, emphasize certain figures and diminish the importance of others. It is a technique with almost limitless possibilities.

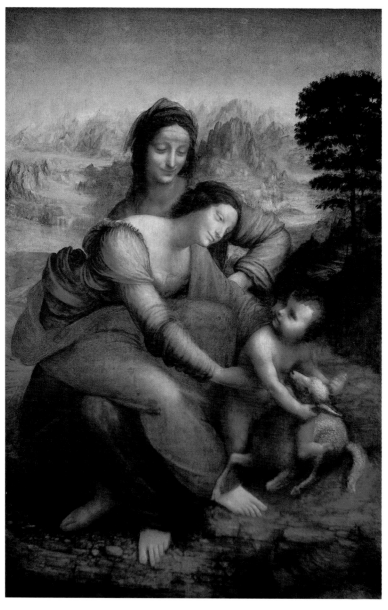

LEONARDO DA VINCI *Virgin and Child with St Anne*

Another characteristic of High Renaissance painting was the grouping of the principal figures in an apparently three-dimensional shape, suggestive of a cone or a pyramid.

The Holy Family is the subject of many paintings and is often presented informally. The little St John, for example, plays with the Christ child and offers him a goldfinch, with a tranquil landscape in the background. The Madonna often appears on a cloud as the Queen of Heaven.

Probably the most spectacular paintings were the huge ceiling decorations, which had remarkable illusionist effects. In the manner known as **di sotto in su** (from below looking up), figures seemed to be flying, or suspended above the viewer's head, or clinging to imaginary structures in the illusory space above. It was a style used mainly for religious and mythological subjects.

Venice

The Venetian Empire had grown steadily from the 11th century onwards, largely as a consequence of maritime trade. Venice was a rich city, and to ensure its further embellishment one of the doges (chief magistrates) gave instructions that every Venetian merchant ship returning from the east should bring back works of art and other objects of beauty.

These art treasures, many of them extraordinarily brilliant in colour, had a strong influence on Venetian painters. This influence is evident in the rich reds and blues which we see in so many of their pictures.

Colour was so important to them that many even dispensed with preliminary sketches and planned their pictures primarily in terms of colour. Even in the shadows colour is apparent. The peculiar light which the waters of the lagoon seem to create is recognizable in many of the pictures.

During the century oil painting superseded tempera, and canvas replaced the traditional wood panel. Canvas was better suited to the damp conditions of the city. It was also easier to transport. This was an important

TINTORETTO *Christ washing the feet of the Disciples* (detail)

consideration, for a number of paintings executed in Venice were commissioned by people living outside the city, some of them in other European countries.

The climate of opinion created by the Counter-Reformation affected the way in which Venetian artists handled religious subjects. The anecdotal and humanizing treatment which had been part of the 15th-century tradition, and which had added charm to the scenes, was now discouraged. The image of the Madonna suckling the baby Jesus, for example, was no longer permissible.

Some painters broke away from the tradition of always placing the Madonna in the centre of the painting.

Florentine painting was based on drawing, Venetian on colour. This, in simplified terms, is the principal distinction between the works of the two great centres of Italian art in the 16th century. In Venetian painting the viewer is much more aware of the brushstrokes and of the way in which colour is used.

Landscapes became more important, although no artist could yet choose a landscape as a subject in its own right. These background landscapes are almost panoramic in effect. The features in them are painted with softened, almost blurred edges. The horizon is blue to

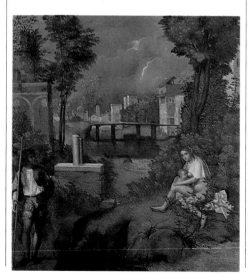

GIORGIONE *The Tempest*
(detail)

indicate distance, and there may be a small town or a cluster of buildings nestling on a hillside, painted in warm, golden tones.

Time has served accidentally to exaggerate this golden quality, for one of the green pigments commonly used darkens irreversibly with age. As a result trees originally painted green now have autumnal colours.

For the first time we see so-called 'mood' paintings, in which the landscape and the sky cease to exist solely as a background and are used to create a particular atmosphere or mood.

For example, in this picture the atmosphere is created by the heavy storm clouds and by the lightning in the sky, which illuminates the landscape and permeates the whole painting.

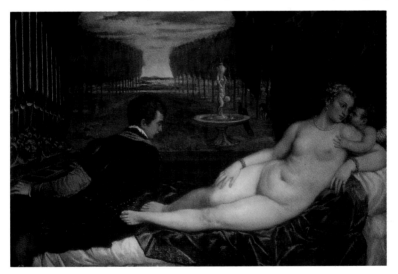

TITIAN *Venus and Cupid with an organ player*

TITIAN *Danae receiving the shower of gold*

Mythological scenes were popular, especially that of the nude Venus lying in a luxuriant and soft countryside. This sensuous, indeed erotic treatment of myths and allegories was referred to as 'poésie'.

These pictures found a ready market abroad. Letters written by Titian to King Philip II of Spain have been found, in which he promised to send him pictures of Venus with a full frontal view as well as side and rear views.

The ceilings of churches and palaces were decorated with highly elaborate illusionary paintings.

Figures are large and numerous and the style and lighting are dramatic.

In some paintings where the background is dark chiaroscuro is used to great effect. The more important figures are brightly lit and seem to be emerging from darkness. The lesser figures disappear into the gloom. Where the background is light the figures furthest from the viewer may be painted to match in tone the impressive architectural features in the background. The most colourful figures in the paintings are often the most important people.

VERONESE *Christ and the doctors in the Temple*

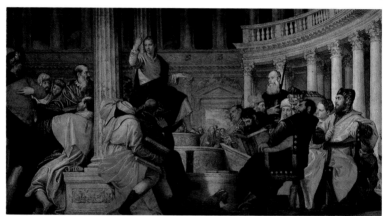

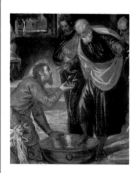

TINTORETTO *Christ washing the feet of the Disciples* (detail)

In 16th-century Venice, drawing from life was already commonplace. Some artists created small models and arranged them in such a way that figures which had to be seen from an awkward angle – for example, angels flying into the scene – could be painted convincingly.

In general, Venetian paintings of the 16th century give an impression of pageantry and splendour which has perhaps never been surpassed.

FLANDERS

Italian paintings were much admired in Flanders in the 16th century and a number of Flemish artists painted in the new Italianate manner.

Architecture and landscape, as well as facial features, became more idealized. The

architecture in the paintings was essentially classical, but some of the details were over-elaborate and reflected Flemish rather than Italian taste. Figures became more muscular, but, as a concession to Flemish fashion, the female figures remained plumper than in Italian art.

Other artists continued to work in the traditional Flemish manner, with painstaking detail and in vivid hues. Occasional Gothic touches such as shot colours or flying angels still appear.

There was a fascination with landscape, which is evident in both paintings and prints. Landscapes dominate many of the pictures, and in some the viewer has to search for a tiny figure who may be the nominal subject of the painting. The landscapes tend to be made up of rocky formations which are painted in cool blues, greens and greys. A sense of great distance is created within a small area.

In the treatment of allegorical subjects numerous nude and semi-nude figures appear, painted in pale colours. They have a fragile appearance and may be set in a landscape filled with mysterious plants and other objects in surprising juxtaposition.

In the second half of the century a number of Flemish artists made proverbs the subject of

VRANCX *The blind leading the blind* (detail)

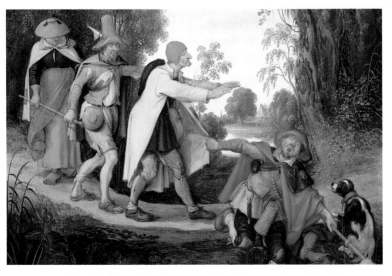

their paintings. Having chosen some common saying, the painter would express it through figures placed in a contemporary setting. Buildings, furniture, countryside and people are all arranged in such a way that the eye moves from incident to incident as related in the proverb. The figures are usually those of well-dressed peasants.

Other themes of paintings are the seasons of the year – winter, for example, being shown by figures skating on ice. The depredations of winter weather are shown in bare trees, broken roofs and turbulent waters.

In the treatment of religious subjects the holy figures are not only represented in a lifelike style, but frequently look like peasants.

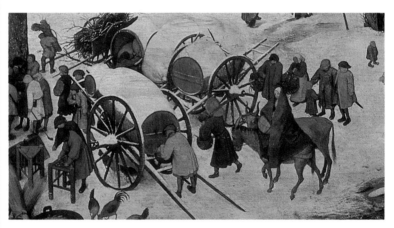

BRUEGEL *The census at Jerusalem* (detail)

GERMANY

In the early 16th century Italian and Flemish influences caused a number of German artists to make the final break with Gothic traditions. Many of the social, religious and political changes of the period are reflected in their paintings.

Great attention is paid to landscapes and the depiction of nature generally. Some paintings show the grandeur of forests and mountains, with conifers dominating the background and dwarfing the figures in the foreground. Others feature animals that have clearly been minutely observed.

Foliage is often bright yellow and white, in complete contrast with the sharp colours in the foreground. Bodies become larger and more muscular. In engravings, in particular, the bodies are rounded almost to the point of exaggeration. In paintings the draperies resemble those of sculpted figures.

One consequence of the Reformation, and of the new practices in Protestant churches, was a decrease in the demand for religious paintings. Instead, more and more portraits were commissioned.

In these, the subjects are often shown against a background of mountains. They may be holding an object or be placed in a setting indicating their character or occupation. They are often shown in three-quarter profile and at

HOLBEIN *George Griesze*

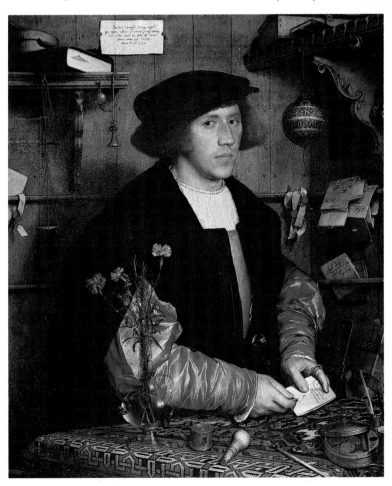

half length. A common feature of these paintings is the presence of a skull, which symbolizes the transience of life. There are also life-size portraits filled with symbolic objects.

In depicting cruelty and anguish some German artists of the 16th century spared the viewer nothing. Demented grief is emphasized by gestures and convoluted drapery. By contrast, moments of supernatural joy are conveyed by yellow, pink and sky blue, representing celestial light, which surrounds figures who have masses of wild, often blond hair and stiff draperies.

Buildings shown in the paintings are complex in style, some being an amalgam of German Gothic, Italian Romanesque and Classical, with individual imaginative additions.

CRANACH *Hunt in honour of Charles V near Castle of Torgau*

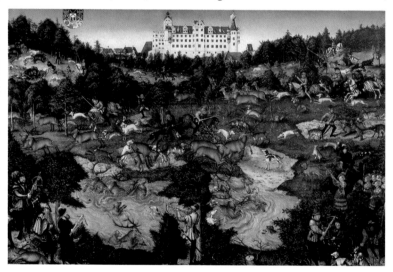

Court artists tended to paint secular, rather than religious, subjects. Hunting scenes were popular. So were mythological themes, in which the human figure would be shown naked or in contemporary German dress. Venus might display her charms wearing nothing but a wide-brimmed, feathered hat.

There are numerous paintings of Adam and Eve after the fall, the general tendency being to blame women for their vanity or voluptuousness. Retribution to come is often indicated by the skeletal figure of death.

ENGLAND

Much of the painting produced in England in the 16th century is directly connected with the powerful Tudor court.

In the early years of the century many of the best artists practising in England came from Flanders or Germany. The portraits they painted ranged from lifesize to miniature.

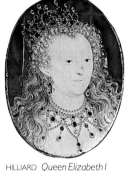

HILLIARD *Queen Elizabeth I*

By the end of the century a number of native English artists specialized and excelled in the production of miniatures, which were painted on card and kept in small, decorated boxes. Alternatively they might be worn as jewellery in the form of a pendant or a brooch.

Elizabeth I, who commissioned many miniatures, made a practice of presenting them to loyal subjects. No matter at what stage of her life the portrait was painted, she herself has not aged.

In full-length paintings figures are dressed in the splendid garments of the time. They may be shown with books or in a room filled with armour, to indicate their tastes and habits. Faces are carefully modelled, and the effects achieved are often both subtle and realistic.

MANNERISM

Such were the achievements of the painters of the High Renaissance that it was natural for their successors to feel that nothing more could be attained in the style which they had perfected.

Not surprisingly a number of painters, seeking new challenges, sought to express themselves in new and unexpected ways.

An important influence was the discovery in the early years of the 16th century of a number of classical Greek statues, in particular the

famous Laocoön group and the so-called "Belvedere torso".

The Laocoön group shows figures in violent action and with highly expressive faces. Both sculptures portray the muscular male nude in precise anatomical detail.

In trying to imitate the same artistic precision in the portrayal of the nude, together with emotion expressed in both face and body,

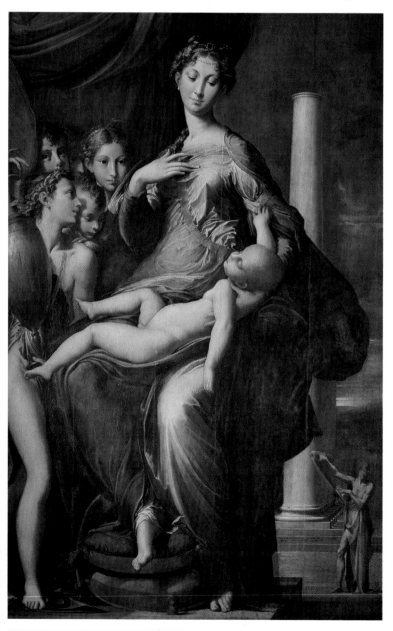

MAZZUOLA *The Virgin with the long neck*

16th-century artists found themselves introducing a new feeling of tension into the calm and harmonious compositions which characterized High Renaissance art.

Twisting figures, with bodies contorted, sometimes elegantly, at other times violently, are seen in poses suggestive of ballet. Many of the figures are elongated, and some appear as if they were seen in a distorting mirror. Chiaroscuro effects are minimized, and consequently colours become stronger. Flesh is portrayed in pale, porcelain-like colours.

There is an increasing use of the nude figure in more and more complex poses, with erotic overtones.

Instead of the pyramidal arrangement in High Renaissance paintings, compositions are opened out. Some artists line up their figures parallel with the picture frame.

Others create a disturbing atmosphere through depicting large figures looming up in the foreground, steep perspective and surprisingly small figures in the background.

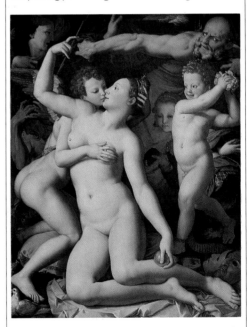

BRONZINO *Allegory with Venus and Cupid*

Some of the Mannerists were highly successful in their own day. They were also greatly in demand as court portrait painters. As such they were concerned with the characters of

the sitters, which they tried to present by pose and gesture, rather than by achieving only an exact physical likeness. Standing in front of some of these portraits, one feels one knows the sitter well enough to begin a conversation.

Equestrian portraits also became fashionable – a vogue which was to influence a number of 17th-century painters.

The Mannerist style lost its appeal soon after the death of its principal artists. It was to gain new recognition in the 20th century when, after World War I, artists were once again looking for new challenges and new ways of expressing themselves.

FRANCE

The centre of the Mannerist school in France was Fontainebleau, to which a number of artists came from Italy. The French developed in time a more erotic version of Mannerism, with a preference for the female nude. Slender, attenuated figures were also portrayed in paintings with allegorical or mythological themes.

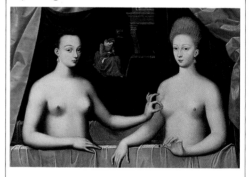

SCHOOL OF FONTAINEBLEAU
Gabrielle d'Este and her sister, the Duchess of Villars

SPAIN

Spanish art in the 16th century was kept under fairly rigorous church control. The most outstanding pictures were some Mannerist paintings. These are characterized by

sumptuously rich and vivid colours, such as brilliant yellow on green.

Figures are elongated and even ethereal, yet at the same time disconcertingly muscular and full of energy. Drapery is painted broadly and does not reveal the figure.

Many of the people shown are dark and round-eyed, with strongly emphasized bone structure, gaunt cheeks and an unnaturally long, seemingly boneless body. The space they occupy seems unreal, and the lighting is surrealist and clearly used for emotional effect. Brushstrokes are easily visible, and much use is made of clear outlines.

EL GRECO *Christ driving the money-changers from the Temple* (detail)

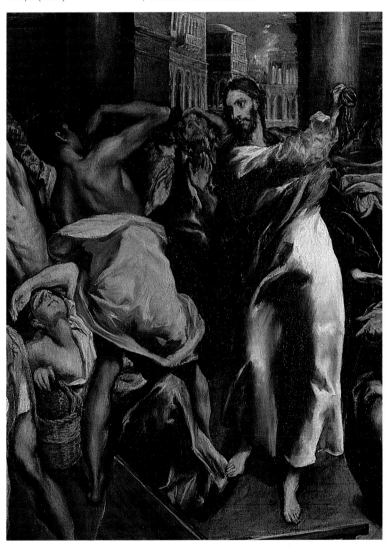

Chronology

THE AGE OF BAROQUE

17th Century

Artists and architects benefited greatly from the renewed strength and confidence felt within the Roman Catholic Church in the 17th century. By then the Reformation had been succeeded by the Counter-Reformation.

Rome in particular was replanned in magnificent style by Pope Sixtus V. Churches, fountains and palaces were placed at focal points in the city. Noble Roman families such as the Barberini, the Borghese and the Colonna rivalled each other as munificent patrons.

Painters came from Spain, France, England and Flanders in search of commissions, and before long Rome had become the artistic capital of Europe. A bohemian artists' colony, which still survives, grew up around the Spanish Steps. Members of this colony led the way in creating new styles and ideas which spread throughout Europe.

The two most important styles were Early Baroque and High Baroque.

EARLY BAROQUE

In the early years of the century some artists reacted against the artificiality of 16th-century Mannerism. Realism was again in fashion, but it was interpreted in a number of different ways. The two most important groups which emerged were the Naturalists and Classicists.

Naturalism

These painters developed a style which was based on extreme realism. Religious stories are

told in a contemporary idiom. The Apostles are no longer heroes, clad in Roman togas, but rough-looking fishermen; biblical scenes are shown in dark Italian streets and in the courtyards of Renaissance palaces.

The details are naturalistic and painted in bright, clear colours. As a rule, artists painted straight on to the canvas without any preliminary sketches.

Sometimes the clergy thought the artists had exceeded the permissible limits. One, for example, for his depiction of the death of the Virgin, took as his model the swollen body of a dead prostitute which had been dragged out of the Tiber. On more than one occasion a commission was revoked.

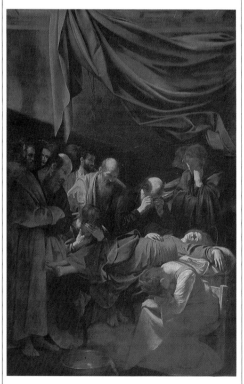

CARAVAGGIO *The death of the Virgin*

In many pictures the figures are close to the foreground plane, and their dramatic gestures seem to draw the spectator into the world of the painting.

The drama is intensified by the almost theatrical use of light and shade. The light falls

from a single source and the effect is that of a harsh spotlight, usually from the left, which is directed on to the scene. The backgrounds become large areas of haunting darkness.

The effects are often startling. A part of a dress may catch the light so that the richness of the fabric becomes apparent. The light may catch the edge of a sword, or linger on the blood falling from a gruesomely severed head.

Many of these pictures show violent scenes, and the black shadows and uneasy patterns of light and shade create a sombre, mysterious mood, sometimes heightened by candlelight.

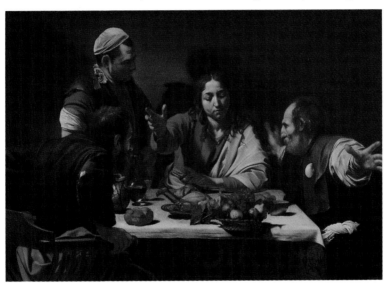

CARAVAGGIO *The supper at Emmaus*

In the painting the two disciples, who have met an apparent stranger on the road to Emmaus, have weatherbeaten faces and torn fishermen's clothing.

They are eating a simple meal of bread and fruit, painted with intense realism; the apples are worm-eaten, the leaves dying. The painting is highly dramatic; the outflung arms of the disciple, boldly foreshortened, reach out towards us.

The bowl of fruit can be seen balancing on the edge of the table so realistically that we instinctively wish to reach out and prevent it from falling. The picture frame cuts off the legs of the chair on the left, so that it seems to stand in our space.

The artist shows the men at the very moment when they realize who the stranger is, and the painting seems to include us in this revelation.

Classicism

Another group of painters who reacted against 16th-century Mannerism looked to the realism of High Renaissance painting and classical sculpture for their inspiration.

These artists adopted the High Renaissance practice of working from preliminary drawings, both for individual figures and for the whole composition.

CORREGGIO *Noli me tangere*

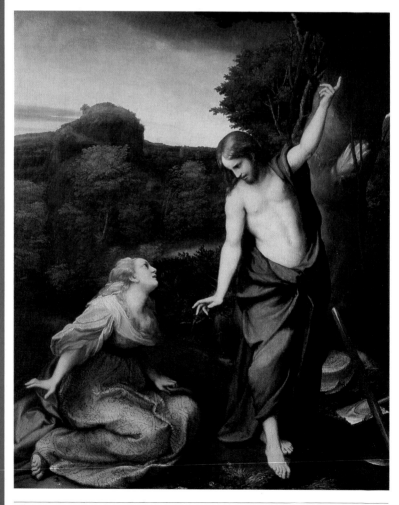

Characteristic features of their work are monumental figures and glowing, sensuous colours suggestive of 16th-century Venetian painting. Figures are placed parallel to the picture plane.

The emphasis is on clarity of expression and gesture and the subtle relationship of one group to another.

This austere Roman classicism was to be developed further by French painters.

Scenes from everyday life

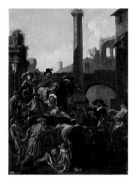

MIEL *Carnival Time in Rome*

The early 17th century saw the introduction of a new form of painting. Artists began to paint scenes from everyday life, and such subjects as butchers' shops were painted with a new, serious grandeur.

Dutch and Flemish artists working in Rome began to paint small-scale scenes of Roman street life. Such works show men playing cards before crumbling Roman ruins; water sellers and pedlars; brigands attacking travellers in a lonely ravine; people pausing at a country inn for refreshment.

HIGH BAROQUE

ITALY

The second phase of Baroque art, dating from the 1620s and known as High Baroque, is characterized by an increasingly exuberant sensuality and magnificence.

Another striking quality is perhaps the feeling of movement. This can clearly be seen in large and crowded pictures with allegorical or religious themes.

Even the twisting, curving flow of drapery has a life of its own.

Within the paintings figures tend to form small groups. Yet these groups merge into larger ones, of which they are an integral part. The whole has therefore a homogeneous quality, with every part in some way related to another part. The link between one figure and another may be physical contact or a gesture or a look. You feel that if you were to remove any one figure the whole composition could collapse.

A High Baroque painting can be likened to a full choir, with all the voices making up the harmony. No single voice is distinguished from the others, and the pleasure comes from the blending and substance of the singing.

In order to take in the whole of the picture the viewer's eye is often led to travel in a broad S-shape. The composition of the paintings is based on strong diagonals and curves.

High Baroque painters also developed new techniques of **illusionism**. Some used painted architectural frameworks, which seemed to open the room to the sky above, and figures appear to swirl in the air both above and below the painted framework.

In the paintings in palaces the subjects are often from pagan mythology; ceilings open up into a vision of the radiant, glowing beauty of the gods of Mount Olympus, painted with sensuous colour and voluptuous charm.

Such ceilings are often playful and witty in their use of illusionism; painted figures gesture and smile at one another across real space; animated figures are seen sitting on the edge of an illusionary balustrade.

Religious art has an obvious propagandist element. In particular, artists were concerned with propagating those doctrines which were most strongly challenged by Protestants: the visions of saints, the lives of the martyrs, and the central position accorded to the cult of the Virgin Mary.

Many High Baroque altarpieces show saints experiencing visions and ecstasy. Yet these mystical visions are made credible through the intense realism with which they are portrayed; the saint is often shown in rapture before the

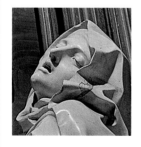

BERNINI *Ecstasy of St Teresa*
(opposite and detail above)

divine, her ecstasy expressed through fluttering, agitated draperies, flickering patterns of light and shade, and exaggerated facial expression.

There is often a suggestion that spiritual love may be expressed through erotic passion.

St Theresa's description of her vision of an angel who plunged a geat golden spear into her heart read: 'When he pulled it out, I felt that he ...left me utterly consumed by the great love of God. The pain was so severe that it made me utter several moans. The sweetness caused by this intense pain is so extreme that one cannot possibly wish it to cease...'

FRANCE

Art in 17th-century France was dominated by the long reign of Louis XIV, the Sun King (1643–1715). The Académie Royale de Peinture et de Sculpture was founded in 1648 and the arts were organized to convey the splendour and power of absolute monarchy.

Versailles was transformed into the most spectacular palace in Europe, and a vast team of painters, sculptors and gardeners worked there on a series of decorative ensembles, every detail of which proclaimed the glory of the king.

French Classicism

A number of French painters worked in Rome and adopted the classical style.

Their paintings suggest the grandeur of a classical world whose stern virtues they admired. Figures are arranged, as in a classical bas-relief, parallel to the picture plane. Drapery is painted in crisp folds which suggest the influence of classical sculpture.

Details such as statues of the ancient gods, drinking vessels and urns help to create an aura of antiquity.

In the background there are often classical cities, with tombs, palaces and temples.

One of the artists' aims was to express the passions of noble human beings as clearly as possible. A characteristic composition shows some dramatic event, and around it the varied reactions of different figures. The expressions and gestures are forceful and dramatic.

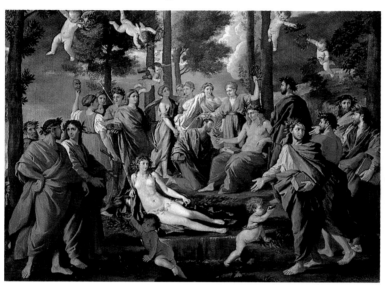

POUSSIN *Parnassus*

In religious paintings, particularly in those of the Holy Family, classical artists continued to develop the grandeur of High Renaissance painting.

The ideal landscape

A new type of landscape painting, called "ideal landscape", was created by French artists working in Rome.

These artists were inspired by the Roman Campagna and the coastline around Naples; they studied the beauty of its majestic trees and hills, and of its changing lights and atmosphere. Yet in their paintings nature is idealized, and their landscapes suggest the enchantment of a vanished Golden Age.

In such landscapes majestic trees frame the foreground; the middle distance is marked by

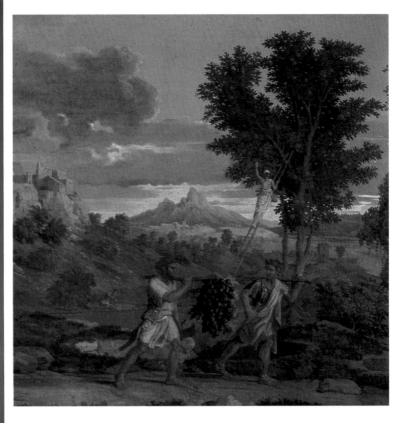

POUSSIN *Autumn, or the bunch of grapes taken from the Promised Land* (detail)

some large feature, perhaps a classical ruin or medieval tower; a sequence of hills leads the eye to a distant vista.

LORRAIN *Pastoral landscape* (detail)

Small incidents are recorded: travellers walking along a twisting path; a small bridge or waterfall; a fisherman drawing in his nets; a carefully placed flight of birds.

The landscapes are unified by the beauty of the light; very often this is the light of the rising or setting sun on the horizon. As the light moves across the painting it creates bright highlights on trees and animals, and throws the foreground into darkness.

The figures of classical nymphs and shepherds suggest the mood of Virgil's pastoral poetry.

Harbour scenes

Another type of painting was the port or harbour scene. In such pictures a stately array of classical and Renaissance buildings create imaginary ports of theatrical splendour; often the red light of the rising sun floods the painting.

Close attention is paid to the movement of the waves and the shifting patterns of light and shade across the water.

Some painters specialized in storms, showing the rugged countryside of the Roman Campagna lit by dramatic flashes of lightning; trees bend in the wind, and human figures and animals flee in exaggerated terror.

LORRAIN *Embarkment of St. Paul at Ostia*

Paintings from everyday life

A number of artists had worked in a realistic style, painting low-life scenes and peasants. These paintings are distinguished by their gravity and dignity, which contrast sharply with the jollity of Flemish scenes of the same genre.

Often a peasant family is shown around a table, sharing a simple meal of bread and wine. The figures are clearly arranged, with a classical emphasis on balanced horizontals and verticals. The mood is sombre, almost sad, and the colours are pale browns, dusky greens and greys.

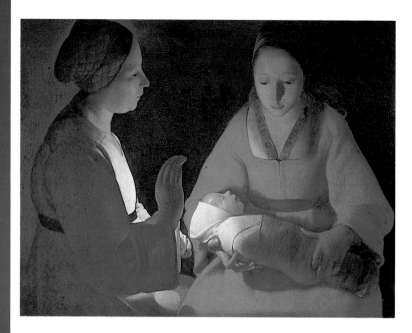

LA TOUR *The new-born*

Other artists painted religious scenes with a tender realism. Often the source of light is a single lighted candle; the forms are simplified, the surfaces smooth, and the light creates an intensely poetic mood.

Portraiture

A similar simplicity characterizes early 17th-century portraiture. There are many paintings which present the sitter with a straightforward realism. The compositions are spare, almost stark, and the colours a sober range of greys and blacks.

FLANDERS

At the end of the 16th century, when the Netherlands were divided into north and south, the southern part, Flanders, remained under the Catholic Habsburgs.

Flemish art expressed the power of the Catholic church as well as the aristocratic splendour of the Habsburg court.

In a series of great altarpieces for churches in Antwerp and Brussels Flemish painters united the grandeur of Italian High Baroque painting with the powerful realism of Flemish art. These altarpieces are frequently painted on panels.

Compositions are often built up around deep diagonals; there is an emphasis on passionate expressions, and the drama of solid, heavily muscled bodies united in violent action.

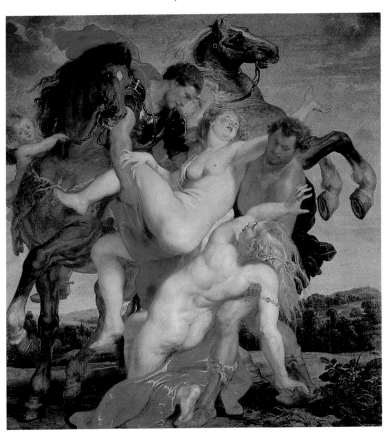

RUBENS *Rape of the daughters of Leucippus*

Many altarpieces show the sufferings and miracles of saints; these show the artist's interest in a wide range of emotional expressions – of pain, joy, terror and despair.

Other pictures express the sophisticated tastes of the Habsburg court. Many mythological paintings, often taking their subjects from Ovid's *Metamorphoses*, were painted as part of decorative schemes for Habsburg patrons. These mythological paintings express a radiant joy in life; the

bronzed flesh of male nudes contrasts with the gleaming, pearly whiteness and luminous shadows of opulent females; the compositions are bound together by flowing movement.

Allegorical paintings

In order to flatter their royal patrons, artists invented new allegories in which the gods of antiquity and personifications of the Christian virtues accompany and obey an earthly monarch.

These are richly theatrical and splendid works, crowded with luxurious draperies and voluptuous figures; a monarch may be accompanied by Fame blowing his trumpet, while before him gods of the earth and sea mingle with historical characters.

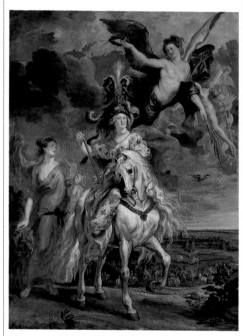

RUBENS *Triumph of Juliers, Maria de' Medici*

Portraits

DYCK *Thomas Wentworth, Earl of Strafford* (detail opposite)

Many portraits show the sitters either seated or standing on terraces, their nobility

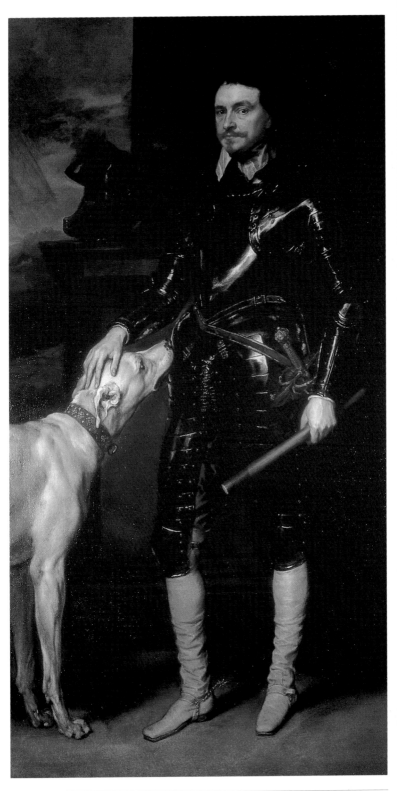

emphasized by the grandeur of classical columns and by magnificent swathes of richly coloured drapery.

Peasant scenes

In other pictures older Flemish traditions persist. There are many scenes of peasant life, some good-humoured renderings of lively outdoor festivals, others the dark and smoky interiors of taverns where men smoke, fight and play cards.

OSTADE *Three peasants drinking and smoking in an interior*

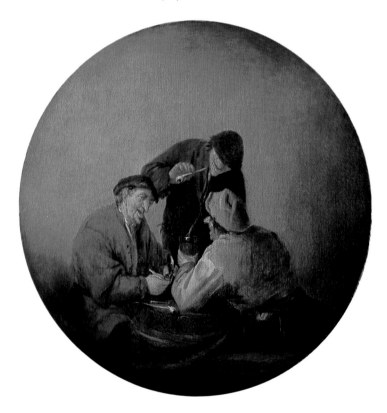

HOLLAND

The principal patron of artists all over Europe had long been the Church. The second most important kind of patron was the powerful aristocrat.

In 17th-century Holland two changes of great importance occurred which left their impact on Dutch art.

One was the adoption of the Protestant faith. The other was the new power acquired by the merchant class, whose members had played a major part in the nationalist fight for independence from Spanish rule.

The Protestant authorities did not want elaborate altarpieces with religious themes for their churches. The merchants, although they sometimes commissioned portraits, did not have the tradition of wider artistic patronage.

Dutch artists of the 17th century therefore had to adopt new practices in order to support themselves financially. Many of them, instead of searching for a patron, painted their pictures first and then went out into the market-place to find a buyer. Today, of course, this is the normal practice.

Fortunately there was a growing vogue, at first among the richer merchants, and then among the relatively comfortable middle class, for buying paintings for their homes and guild halls.

To take advantage of this, artists tended to specialize in certain types of painting. This helped to make their work easily recognized and their names well known.

The results are evident in the interiors, still-lifes, landscapes, seascapes and portraits which characterize Dutch 17th-century painting.

Interior scenes

The representation of a commonplace domestic scene in a middle-class Dutch home is one of the most typical and most easily recognizable examples of the Dutch genre paintings.

The paintings for the most part reflect everyday life in 17th-century Holland. The subjects are often family events such as weddings and christenings. Women are shown engaged in domestic duties, writing letters or playing music.

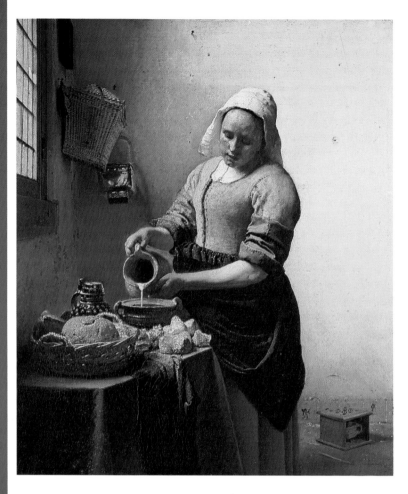

VERMEER *The maid with the milk jug* (detail)

The rooms in these paintings are uncluttered. Each piece of furniture seems to have been carefully chosen and placed in exactly the right position. Floors are usually tiled in stone, and their patterns lead the eye to particular points in the picture. Traditional Delft tiles often surround the fireplaces. Everything seems spotlessly clean.

The style is wholly realistic and the form of presentation exact in every detail. One's immediate impression is that in each case the artist came into the room unexpectedly and, like a camera, took a picture of what he saw.

Many of the pictures portray scenes of a serene and happy family life. By contrast there are equally convincing pictures of the interiors of inns and brothels. In these, life is seen at once to be coarse, vigorous and noisy.

A number of the artists were clearly interested in architectural perspective. In some of their paintings the eye is led through doorways to adjoining rooms and courtyards.

Even more apparent is the preoccupation of the painters with the effect of light falling on objects of different textures. Polished wood glows softly. Rough wool absorbs light. Satin sparkles and crackles. Glass catches the rays and reflects them back into the room.

It is the masterly handling of light, above all, which gives so many Dutch paintings their unique quality.

Landscapes

Dutch landscapes and marine painting reached an extremely high level in the 17th century.

The sky in different moods dominates many of the paintings. This is not surprising in a country which is nearly all flat and where from every viewpoint one is aware of the seemingly endless sky. In some of the paintings it is calm and appears almost as a continuation of the orderly landscape. In others, raging storms in the sky set the mood for the painting.

The landscapes dominate the paintings. Figures and buildings are few and small and blend easily with their environment.

There were a number of different schools, but the style of all of them was realistic.

Tonal landscapes. Some pictures, known as tonal landscapes, were painted in monochrome with a very narrow range of subtle modulations in tone. Colours are mainly shades of browns and greys. Small amounts of strong colours, such as red or blue, are used to highlight details and to lead the eye. Horizons are low, and the painters paid special attention to the atmospheric effects of light.

Heroic landscapes. In later landscape painting stronger colour returns. The mood is more dramatic and the treatment more emotional. Symbols abound, particularly those calling

attention to the transitory nature of man's existence. Forests and huge, magnificent single trees are features of the landscapes.

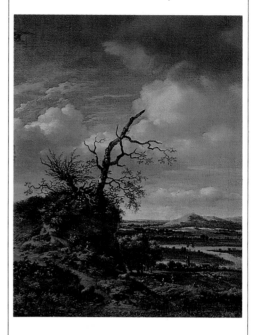

WYNANTS *An extensive river landscape*

Early in the 17th century some northern artists who travelled south painted the more dramatic aspects of the countryside, depicting small towers on rocky cliffs, footbridges over perilous ravines and alpine peaks. These landscapes, with sharply defined objects and bright local colours, often have brown foregrounds, green middle distances and sharp blue backgrounds.

Italianate landscapes. A number of Dutch artists either worked in Italy or came strongly under Italian influence in their own country.

Later Dutch artists admired above all the beauty of the Italian light and, even when painting Dutch landscapes, would enrich them with a hazy golden glow.

Seascapes

In the 17th century Holland became an important maritime power, and the part the

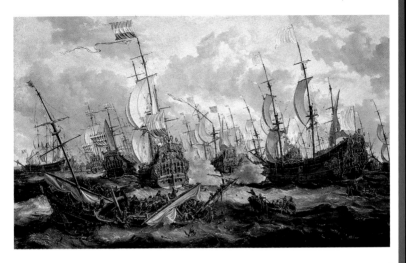

STORCK *The four-days' battle*
(above and detail below)

sea played in national affairs is reflected in the painting of the time.

The style of seascape painting was similar to that of the landscape artists. Characteristic seas along the shallow coast and in the estuaries are faithfully presented. Some are calm, others grey and stormy, with boats pitching and rolling; the sky is as important to the artist as it is to the mariner. The ships and their equipment are depicted with painstaking detail.

Recent naval battles and other maritime events were among the subjects of the paintings. This was a novelty. Earlier artists had considered only the battles of antiquity to be suitable subjects. Dutch marine painters, by contrast, went aboard men-of-war and were among the first true war artists.

Still-life paintings

Still-life pictures became popular in Holland in the 17th century, when few religious pictures of the traditional kind were being painted.

The modern viewer tends to judge Dutch still-lifes simply by the intrinsic beauty of the objects painted and by the skill with which the artist has arranged them. He is seldom aware of their symbolic or other significance.

Many of the still-lifes are of the so-called **Vanitas** kind, the name being taken from the

famous passage in Ecclesiastes: 'Vanity of vanities; all is vanity.' The objects depicted in these paintings are ephemeral or tell of the passing of time: butterflies and guttering candles, skulls and hourglasses.

The symbolism in other still-lifes, which show bread and wine, is more specifically Christian.

In the latter part of the century artists began to paint more luxurious kinds of still-life. In place of the bread and herrings of the 1630s we find gleaming silver and glass, exquisite work wrought by goldsmiths, oriental carpets and nautilus shells. All this reflects the increasingly aristocratic taste of the Dutch burgher class.

Portraiture

Early 17th-century portraits by Dutch artists tended to be stiff and posed, with meticulously realistic treatment of features and fabrics.

In the 1620s a new informality becomes apparent. The artist's viewpoint varies. Sometimes the sitter is seen from below so that he appears to tower over the viewer. In other pictures he is caught in a relaxed pose, leaning on the back of a chair or drinking a glass of wine.

There is a brilliant freedom in the technique. Brushstrokes zig-zag across the surface, creating an effect of movement and catching fleeting expressions of laughter.

There are also more sombre works in which chiaroscuro is used to create a mood of meditation. A strong light falls on one side of the sitter's face; the other side is in darkness, and pools of shadow collect around the eyes.

Double portraits were common, and many were painted to commemorate marriage. Some show husband and wife, three-quarter length, on separate canvases, yet clearly linked to each other. The man tends to look out of the composition, while the woman is more stiffly posed and looks towards her husband.

HALS *W. van Heythuyzen* (detail opposite)

REMBRANDT *An oriental, probably Isaiah* (detail)

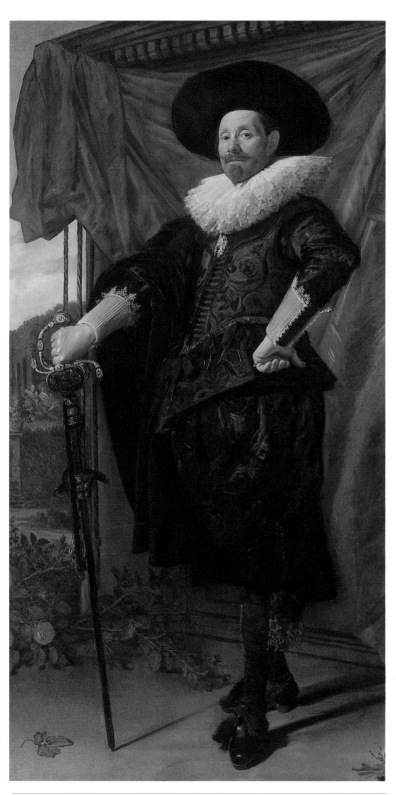

Group portraits were commissioned by such bodies as the members of a militia company or the governors of a charitable organization or a guild. In contrast with the dull rows of undifferentiated heads to be found in earlier group portraits, the scenes in paintings of the 1620s are much livelier.

The figures are split into carefully balanced and juxtaposed groups, linked by sweeping diagonals, and unified by the brilliant colours of sashes and banners.

Other groups are shown in moments of significant joint action. Members of the surgeons' guild listen intently as the master surgeon demonstrates the muscles of the arm; a militia company marches to the sound of drums. The use of chiaroscuro gives a unity to the group.

REMBRANDT *The anatomy lesson* (detail)

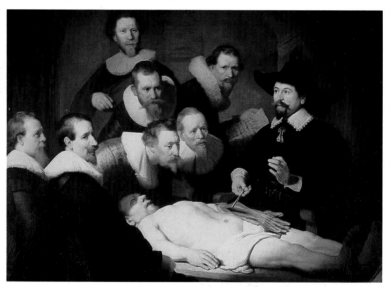

SPAIN

A great age – perhaps the greatest age – of Spanish painting began in the late 16th century in the reign of Philip II, who established Madrid as the Spanish capital. It continued through the 17th century.

The great strength of the Catholic Church in Spain is evident in much 17th-century art. Theorists wrote at length on the correct way to depict religious subject matter, and some artists carefully followed the guidelines laid down. Others interpreted them more freely.

Spain had been slow to afford the kind of recognition and social esteem to painters which they enjoyed in Italy. It was not until 1677 that Spanish painters, through a successful court case, won exemption from the sales tax which leather-workers, builders, butchers and other craftsmen and tradesmen had to pay.

Some painters showed a strong predilection for the pleasanter aspects of life, avoiding harshness even in their religious paintings. This tendency causes some pictures to verge on the sentimental, but they are usually saved by the sheer beauty of the artist's handling of his subject, the compositions, and the sensitivity that is evinced.

A number of Spanish painters visited Naples, which was then under Spanish Habsburg rule and where the influence of the **Naturalistic** school of painting was dominant.

Some of the paintings produced under Neapolitan influence tended to be starkly realistic. The models chosen, particularly for religious works, were sometimes thought indecorous. The painters' technique was vigorous, and strong chiaroscuro effects made objects stand out in a manner which has even been described as 'brutal'.

As the painters gained confidence a specifically Spanish style began to emerge, and Indians from the New World became recognizable in some of the religious paintings. Seville, a city which had strong links with the Americas, became an important artistic centre.

In some of the paintings the interiors of comparatively humble homes, and even kitchens, are depicted with a dignity and seriousness normally associated with far grander settings. A garlic clove, a dead fish or a pitcher are all rendered with care and attention.

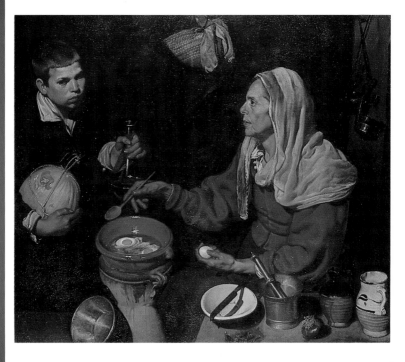

VELÁZQUEZ *Woman cooking eggs*

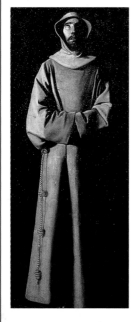

ZURBARÁN *St Francis of Assisi*

Warm tones predominate in the artists' palettes, russets, browns and ochres being much in use.

Other Spanish painters combine naturalism with an austere dignity, which is achieved partly by simplification. The figure of a monk at prayer, for instance, may have a strong light shining on it, yet the face will be in the shadow of the sharply modelled cowl.

Court painting

There was demand among royal patrons for the depiction of contemporary events and settings, such as an enemy's surrender after a battle or the interior of a palace. Above all, there was a demand for portraits.

The court, once it was established in Madrid, laid down firm rules on etiquette and dress, which artists were obliged to follow and which must have inhibited a number of them. Some, however, seized the opportunity to present a wide range of court personages, from dwarfs to the king or queen.

The grounds varied from ochre-brown to reddish to off-white, which was unusual at the time. Brushwork is free and spirited. At least one painter was said by his contemporaries to have worked with long brushes, like broomsticks, just as an earlier Venetian artist had.

Today we can only admire the way in which some of the Spanish painters created an illusion of reality, especially in articles of clothing such as a sash or a collar, through thick, creamy **impasto** scumbled over a darker surface or the most delicate washes of paint.

VELÁZQUEZ *Las Meninas*

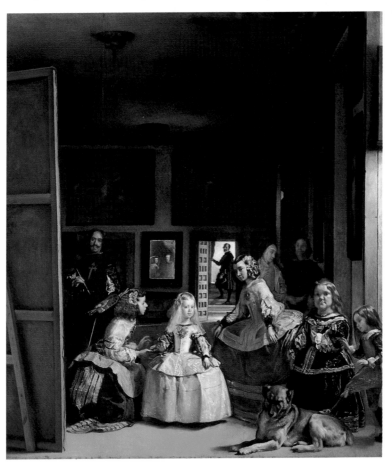

Chronology

THE EIGHTEENTH CENTURY

The Rococo style was fashionable early in the 18th century, and was succeeded by Neoclassicism towards the end of the period.

ROCOCO

FRANCE

France was one of the first countries in which Rococo painting became popular.

Rococo was to some extent a reaction against the Baroque pomp and grandeur of the court of Louis XIV. Towards the end of his reign a new kind of regime was established when Mme de Maintenon became his last mistress. She was a deeply religious woman with strong opinions, and even the Commedia dell'Arte was banished from Paris under her influence.

ZUCCARELLI *The rape of Europa* (detail)

The Rococo style is associated with the reign of Louis XIV's successor, Louis XV.

Rococo painting has a peculiar sparkle of its own. Colours are light, with much use of white and silver. Other favoured colours are dusky rose, pale lemon, misty blue and turquoise. There is not much gold, which is a fairly heavy colour. Instead a great deal of yellow and orange is used.

S- and C-curves frequently appear in the composition of the pictures: in the way in which a curtain is draped, a cloak falls or a figure is twisted.

VIEN *Suzanna and the elders*

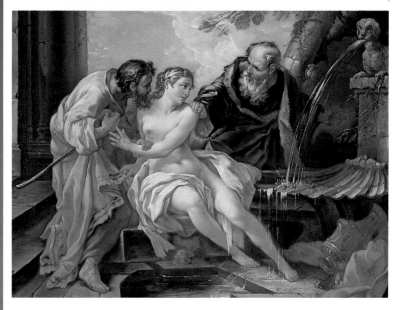

Although the favourite subjects are stories from the Old Testament or from ancient history, there is a more light-hearted approach both to the subject matter and to the presentation than in earlier styles.

Many of the figures are dressed, irrespective of their period, in exotic mixtures of mock-oriental or pseudo-16th-century garments. However, such historical inaccuracies are compensated for by the sheer beauty of the paintings.

Some of the artists worked with remarkable speed. One famous painter enjoyed the reputation of being able to finish a painting while others had scarcely mixed their colours.

PALAZZO REALE, TURIN *Chinese Room ceiling*

Rococo was regarded by some as the last phase of Baroque, and indeed the two styles have a number of features in common, such as illusionist ceiling paintings.

A feature of these paintings is that the demarcation line between wall and ceiling is often blurred. Sometimes the ceiling seems to have disappeared completely, and instead we look at an entirely new vista.

In churches and palaces artists created vast, airy allegories painted with apparently effortless ease. Figures seem to take off into space, their journey upwards plotted in a series of curves, counter-curves and linking diagonals.

An illusion is created of limitless space glimpsed between silvery columns in an azure sky. Figures are clothed in flowing garments of pastel shades.

Later in the 18th century, when Neo-Classicism had replaced Rococo as the fashion of the time, such paintings of fabulous fantasy worlds were considered dishonest.

Fêtes Galantes

When the painting *Embarkation for the Island of Cythera* was submitted to the French Academy a new classification of 'Fête Galante' was coined. The term became popular among

other artists and was soon used to describe a distinct type of painting.

Fête Galante pictures tend to be small and informal. The subject is always a social event which takes place out of doors.

WATTEAU *Homage to love* (detail)

In the paintings people drift through parks which are as dream-like as the characters themselves. They are often overlooked by statues or garlanded busts, which are more evidently alive and erotic than the living beings.

The characters are usually drawn from high society, but may be dressed as actors from Italian comedy or some other theatre.

It is in these Fête Galante pictures that we see for the first time the clown presented as a pathetic figure.

Brushwork is free and varied. Quick, pencilling strokes create the texture of the

dresses, with multi-coloured pigments interspersed to create the iridescence of silks and satins. Warm grey is often used for the ground.

Decorative paintings

Concurrently with the Fêtes Galantes another new type of painting made its appearance in France. This was probably a direct consequence of the fact that a number of well-known painters were engaged to create designs for tapestry and porcelain factories.

Their paintings have bright colours and a vivacity which would translate well into porcelain and tapestry alike. Women are erotic figures. Foamy clouds, rather like soap bubbles, drift across a landscape. Frothy streams, trees which are a deeper blue than the sky, improbable shepherdesses, bright pigments on leaves and flowers all contribute to the attraction of these paintings.

Portraiture

In portrait painting, as in other Rococo pictures, the approach tends to be informal. Sitters are usually seen out of doors. A sparkling light shines evenly over both the sitter and the landscape in the background. The texture of silks, satins and laces seems to reflect the light-hearted mood of the Rococo style. It is a style admirably suited to portraying the beauty of women and children.

In Britain the compositions are sometimes more ambitious than those of French Rococo. There is more animation, partly achieved through a more subtle play of light. The sitters have an air of cosmopolitan polish and breeding.

The brushwork is controlled and the surface of the canvas so smooth that it looks almost polished. It is a painting technique described by

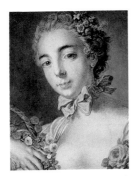

BONNET *Tête de Flore, portrait of Mme Boudion, daughter of Boucher*

a contemporary writer as 'rather lick't than pencilled'.

Later in the century brushwork becomes more varied, colours richer and portraits more convincing.

NEOCLASSICISM

FRANCE

In total contrast with Rococo, the dominant influence in the latter half of the century is that of classical Greece and Rome. As Goethe put it, 'the demand now is for heroism and civic virtues'.

The Paris Salon, which was responsible for exhibitions of paintings by the members of the Royal Academy, stressed that art should be governed by rational rules and not by uncontrolled feelings. Rococo was seen as hedonistic and self-indulgent.

DAVID *The oath of the Horatii*

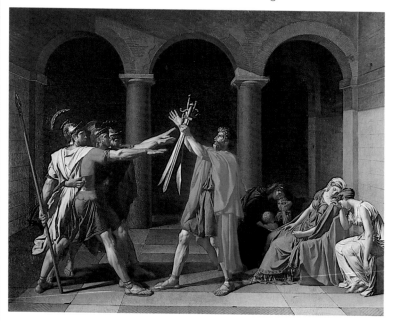

In Neoclassical art, spare but precise outline drawings served as a preliminary to the finished painting. Figures are posed parallel, instead of diagonally, to the picture plane.

Whereas in Baroque and Rococo paintings the contours are formed by shading, in Neo-classical pictures they are created by unbroken lines, interrupted neither by light nor by shadow. Brushwork is smooth and does not break up the surface of the painting. A sense of order prevails everywhere.

Subject matters were chosen largely for what was thought to be their elevating quality. Many were taken from ancient history, mythology or the Bible. These were regarded as the most prestigious paintings, while, at the other end of the scale, still-life was considered a 'drollery'.

Nobility is depicted more often by restraint and understatement than by overt drama. Figures are grouped in a pyramid shape or linked by gestures. Backgrounds tend to be suggestive of stage sets, with arches, columns or ruins from classical architecture.

There is a complete avoidance of any form of illusionism. Colours tend to be clear and bright.

Portraiture

Portrait paintings are half- or full-length. Contours are continuous and unbroken. An even light illuminates the figure and the background alike, and consequently there are few shadows to create depth.

DAVID *Mme Recamier* (detail below)

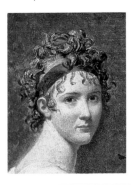

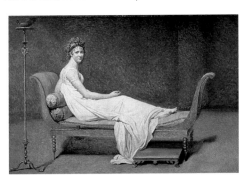

The ground is usually light, often beige, and washed with a liquid diaphanous layer of another colour, often grey, creating a pearly glow in which the figure seems isolated.

Spontaneity may be conveyed by a sudden turn of the head or some other gesture, or by a careless oversight, such as powder which has fallen from a wig on to a coat collar.

BRITAIN

In Britain the sitters, who were mainly important personages, were treated by the painter in the **Grand Manner**, reminiscent of 18th-century Baroque portraits.

The paintings give us more than just a good likeness. Pose, gesture and setting combine to convey the status and character of the sitter. An actress, for example, may be painted in one of her famous roles.

HAMILTON *Mrs Siddons and her son in The Tragedy of Isabella* (detail)

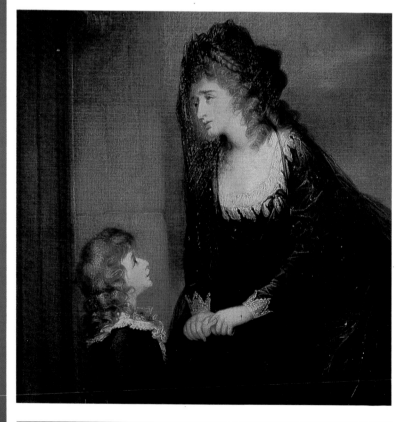

A certain intellectual snobbery was displayed by some of the painters in their deliberate use of allusions to old masters and the antique – allusions which could be understood and appreciated only by the well-educated.

Landscapes

Traditionally, landscapes had been used only to fill in the background of a painting. Gradually, as techniques improved, landscapes became increasingly important to the artist. But the public was still only prepared to pay money for pictures in which the landscape was part of a subject painting, and artists had to comply with its demands.

Towards the end of the century a number of artists were commissioned to paint the country estates of landowners. Many of these works were executed in watercolour.

Others continued to depict the countryside as a background to portraits. Some composed landscapes in swinging Rococo curves, using paint diluted with turpentine to almost watercolour transparency. They are often lit by a silvery light and have small touches of rich colour.

A few artists did paint landscapes without any other subject matter, but they did so for their own pleasure. Many were painted in the Italianate style, with trees and bushes framing the picture on both sides and a vista between them bathed in golden sunlight.

Sporting life

Sporting paintings were fashionable during much of the 18th century. Favourite hunters and racehorses were immortalized, and other animals were also featured. In one painting a dog and a prancing monkey illustrate a contemporary fable, in which the noble

country animal is contrasted with the foppish court one.

There are paintings too of fighting animals. These pictures are conceived in a heroic spirit and executed with a classical restraint, which is reflected in the refined linear design and pattern of light and dark colours.

STUBBS *Horse attacked by a lion* (detail)

Conversation pieces

Conversation pieces are essentially group portraits. Usually a whole family is included in the picture.

Many of the sitters in these conversation pieces belonged to the rich middle classes. Their homes, the usual setting for the painting, reflected their tastes and aspirations.

The family may be seen in the interior of a Palladian mansion, complete with books and portrait busts, all indicating good taste and refinement. Alternatively they may be painted in the grounds of their country estate, perhaps drinking tea, which at the time was indulged in only by those with both money and taste.

Occasionally, suitable furnishings were borrowed from the artist's props. This explains why the same table, for example, appears in more than one home.

Children, by way of change, are painted not as miniature adults but as real children, who climb trees, play with their dolls or build a house of cards.

Occasionally what were known as 'lay figures' were used by the artist. These were

DEVIS *The Rookes-Leeds family* (detail opposite)

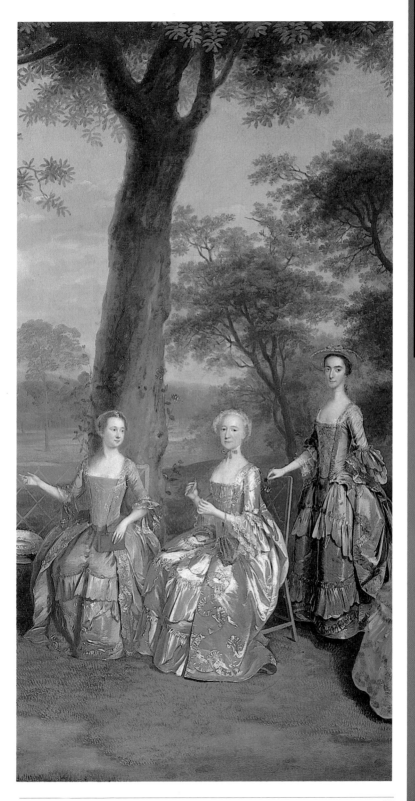

small dolls with jointed arms and legs, which could take up any position. Suitably dressed, they were used as stand-ins for the sitters.

The use of these lay figures can sometimes be detected through a slightly unnatural-looking arm or leg, or by the way some of the figures seem not to communicate. Some portrait painters also made use of dolls or lay figures.

Moral pieces

These were group paintings which often satirized people at different levels of society, from harlot to nobleman. As a rule the characters were fictitious, but sometimes a

HOGARTH *Marriage à la mode – shortly after the marriage* (detail).

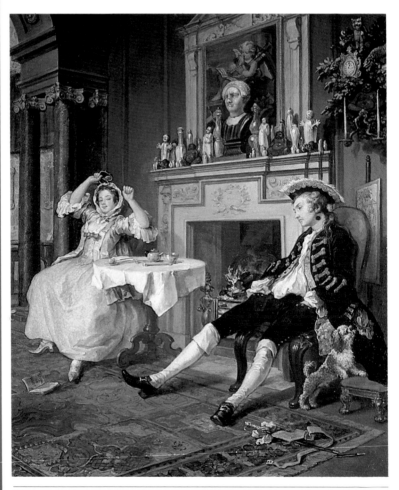

notorious individual such as a crooked judge or a brothelkeeper might be included.

These paintings appeared mainly in series or in contrasting pairs. They have something of the appearance of stills from contemporary plays, each detail contributing to the unfolding of the story.

Moralist painters made most of their money from the prints sold through booksellers. These were not expensive, and some sold in large numbers.

ITALY

Townscapes

In the 18th century the word 'townscape' suggested to many a picture of Venice. Paintings of Venice were bought by many of the visitors to the city and became treasured possessions in numerous European homes.

The paintings were for the most part realistic, in spite of the fact that some artists incorporated two or even more viewpoints in the same picture.

Some of the later 18th-century paintings of Venice were more impressionistic and perhaps

PANNINI *The Piazza Navona in Rome*

more appealing as a result. In many a misty atmosphere is conveyed by grey-green washes of colour. The sun, as it breaks through, sparkles on the canvas through tiny touches of bright, creamy paint.

In the early 18th century townscapes were also a popular art form in Rome. Some of the paintings are archaeologically accurate, others rather more fantastic.

A view of the Pantheon, for example, would not only convey its impressive size and classical proportions. The picture would also be enlivened by a dramatic fall of light and by bright touches of colour in the broadly painted figures.

In Rome as well as in Venice – and later in other Italian cities – fantasy views became increasingly popular.

All these paintings of townscapes were completed in the artist's studio, but the original drawings were done on the spot. One master drawing might serve for several paintings over a period of years. Each painting carried complete conviction, even where the building depicted had fallen down in the meantime.

Sometimes a camera obscura was used to fix the main lines of the view.

SPAIN

In Spain there is a partial breaking away from the highly finished execution and somewhat enamelled surface of much Neoclassical painting.

An almost disconcerting honesty is to be found in some of these Spanish portraits, revealing the weaknesses and human frailty of the sitters. Nobody is spared, not even the Spanish royal family.

In some of the paintings it seems that the Neoclassical and the Rococo meet. Laces and muslins are rendered with an exquisite regard for transparent texture. Touches of brilliant colour in creamy pigment not only depict

GOYA *Charles IV and his family* (details opposite and below)

jewellery and other adornments convincingly; they also enliven the surface of the canvas in a breathtaking way.

In other works figures are more broadly brushed in with liquid paint against a shadowy interior or a brilliant blue sky.

Genre and still-life paintings

Small domestic interior scenes, without any moralizing undertones, became very popular in Spain and elsewhere in Europe. The pictures give us an interesting insight into 18th-century homes ranging from a Venetian courtesan's salon to a respectable French household.

In one picture young boys play cards. In another a teacher instructs a child. A small, protected world is evoked by quiet, muted colours and carefully constructed shapes.

In a Spanish painting a box of quince paste may be seen against the lustrous texture of fruit or the shiny substance of metal.

CHARDIN *The young schoolmistress* (detail above)

Chronology

1812	The Battle of Borodino follows the French invasion of Russia
1815	The Congress of Vienna settles European frontiers at the end of the Napoleonic wars
1816	René Laennec invents the stethoscope
1823	Beethoven completes his Ninth Symphony
1823	The Monroe doctrine of non-intervention is proclaimed in the USA
1824	The death of Byron at Missolonghi
1825	The opening of the Stockton-Darlington railway, the first to carry goods and passengers
1832	Samuel Morse invents the telegraph
1848	The Californian gold rush
1859	The publication of Darwin's *On the Origin of Species*
1861	The outbreak of the American Civil War
1861	The serfs are freed in Russia
1864	Henri Dunant founds the Red Cross
1869	The Suez Canal is opened
1874	The first Impressionist exhibition is held in Paris
1885	Karl Benz builds the first motor car
1895	Marconi transmits the first wireless signal.

THE NINETEENTH CENTURY

Nineteenth-century painters had certain practical advantages denied to their predecessors. They had a wider range of colours and paints became much easier to use, thus facilitating outdoor painting.

Emerald green, for instance, was a discovery of the 19th century. It was vivid and soon became popular, though it was generally replaced in the second half of the century by viridian, which was less toxic. Artificial ultramarine, cobalt blue and violet also became available around the middle of the century. These all combined satisfying colour with stability.

Pigments were available in powder form, in jars or mixed with oil in pigs' bladders at the beginning of the century, but they were cumbersome to transport. Only with the invention of collapsible tubes in the 1840s were artists, both professional and amateur, adequately equipped to paint almost wherever they chose.

Among the principal artistic movements in the first part of the century were Romanticism, Realism and Naturalism.

ROMANTICISM

In painting, as in other art forms, the essence of Romanticism is the belief that the heart and the imagination are more important than cerebral logic. This leads to the practice of listening to the message within and projecting the artist's own personal vision. The weaknesses which may result include sentimentality, lack of discipline and a tendency towards melodrama.

GROS *Napoleon Bonaparte visiting the plague-stricken* (detail)

In their techniques, 19th-century Romantic painters revived the great traditions of Baroque painting, adapting them to the treatment of a wide range of subjects. They made similar use of the diagonal in composition, strong light and shade, dark interiors permeated by light, and deep and rich colours. Occasionally figures seem to emerge from a deep three-dimensional space to be pushed right up to the viewer.

GERICAULT *Officer of the Hussars*

GERICAULT *Officer of the Hussars* (detail)

In the battle between line and colour the Romantics favoured colour. Paint was applied with quick brushstrokes to give a brilliant effect. Sometimes hues of the same colour were juxtaposed to give added brilliance.

The Romantics often chose subjects which lent themselves to dramatic treatment. Some were drawn from contemporary life; these included political scandals and glaring injustices, but also featured quite commonplace occurrences.

Medieval history was given a new, romantic treatment, subjects from Dante, Boccaccio and Tasso being popular. Tragic heroes appear frequently, and there is a tendency to sympathize with the victim rather than the victor. There is a melancholy quality in battle scenes, and history is not uncommonly presented without heroes.

Wild animals, both the caged and the hunted, are popular subjects.

BREAKAWAY GROUPS

Nazarenes

A group of Viennese painters broke away from the mainstream and formed a brotherhood known as the Nazarenes. They went to Rome to live in a deserted monastery, where they dressed in eccentric fashion and, in their work, revived certain medieval workshop practices.

Much of their painting is deliberately primitive and naive in style, with frequent use of the pale but bright ice-cream colours of fresco and tempera.

The influence of this group was considerable, particularly on British and French artists who visited them in Rome. British artists learnt the technique of fresco painting, which they used on public buildings in Britain to depict historical subjects. The results in the damp British climate were mostly disastrous.

Much of the group's painting was religious in theme and evocative of early Christian art. The

early 19th century did indeed see a revival of religious painting of a kind which had been largely neglected in the 18th century.

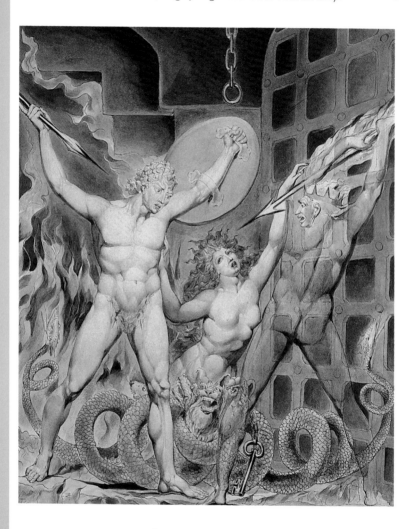

BLAKE *Satan, Sin and Death*

Quite independently of the group in Rome and their imitators there were artists in Britain who chose their subjects from the Bible and the Middle Ages, as well as from literature, particularly Shakespeare. There is a strong element of mysticism in their work, and their view of religion is very personal. They used tempera and fresco, preferred watercolour to oil, and developed a unique form of colour printing.

The Pre-Raphaelite Brotherhood

In Britain, seven artists and writers formed a group known as the Pre-Raphaelite Brotherhood. They considered Raphael overpraised and much 16th-century art insincere. Their own work is characterized by the use of bright colour painted on a white ground and sometimes worked into wet paint.

 Their initial call was for truth and honesty in art, but as the century progressed their

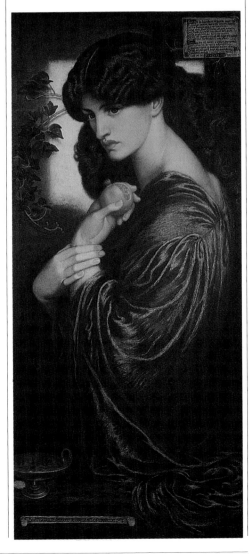

ROSSETTI *Proserpine*

subjects grew more remote and their treatment more elaborate. They are perhaps best known today for their ideal of feminine beauty, which is presented in rich and decorative settings. The models they used were not professionals, but their own friends or mistresses.

Portraiture

Some of the greatest 19th-century Romantic paintings are portraits, which range from full-length to head and shoulders. Sitters are often seen out of doors, perhaps against a stormy sky and with windswept hair. Some of the women look delightfully at ease, and the men often have a dashing appearance.

Even in state portraits there is a certain informality, the task of the artist being, as one of them put it, to seize the expression rather than copy the features. The sitter often gives the impression that he or she has been taken unawares.

Paint is often applied thickly. A glossy surface is created with shiny black, lacquer reds and touches of glittering white.

Some German artists created portraits in the manner of 15th-century northern European painters. In these a half-length figure looks at us through an opening or niche, with a minutely depicted view seen through a window behind. The style is consciously naïve.

Landscapes and seascapes

Throughout 19th-century Europe landscape became more and more important as an art form in its own right and not merely as a background to other painting.

What was known in the 18th century as the sublime – as opposed to the beautiful – in nature, e.g. craggy cliffs, precipitous mountains, barren plains and storms, especially at sea,

attracted more and more painters. Sketching tours in one's own country or, after the Napoleonic wars, abroad became popular, particularly with younger painters, who painstakingly recorded what they saw.

Some used the landscape itself to tell the story, often in terms of the forces of nature and the puniness of man in the face of them. Sometimes one can detect allusions to contemporary events and to social and political changes.

In both landscapes and seascapes colours tended to become increasingly brilliant, with little tonal contrast. 'Tinted steam' was a term used to describe the opaque, semi-opaque and transparent veils of colour through which some painters achieved the effect of brilliance.

CONSTABLE *Salisbury Cathedral from the meadows* (detail)

TURNER *Rain, steam and speed – The Great Western Railway* (detail)

Some German painters created a kind of landscape which was both visionary and symbolic. Objects are depicted with great precision and detail, but in other respects there is a break with tradition. Instead of the eye being led to the distant view, mountains rise up, stark and jagged, in the foreground, and there may be a weird glow of brilliant light behind.

FRIEDRICH *The cross in the mountains*

We are invited to look up at a lonely cross perched on a mountain-top or down to the vast emptiness of a beach with a single solitary figure.

REALISM

Nineteenth-century Realism was a movement whose influence was apparent in a number of

the arts, most strongly perhaps in literature and painting. Its adherents wanted to create a new, living and popular art, which would reach a wide public. They were determined not to be dominated by what Karl Marx called 'the tradition of dead generations'.

Subjects were chosen from everyday life. Village girls, a peasant family at dinner, the sick, the poor and even the mentally retarded were all considered suitable subjects. In some Realist pictures peasants appear as dour shapes against a distant horizon, the shadowed hollow of their eyes being as expressionless as the pose of their figures.

A number of the paintings resemble contemporary photography in their flat tones, relative absence of modelling and strong contrasts of light and shade. In others, dense, solid paint is applied with a palette knife.

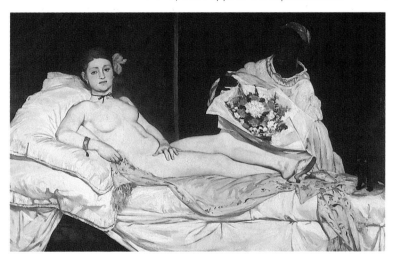

MANET *Olympia* (detail above)

Many members of the public, who were used to more genteel styles, felt that the Realists were degrading art. Their treatment of the nude caused particular offence. Nude figures in mythological settings were acceptable. The shock came when naked women were portrayed in a contemporary and familiar setting. To heighten the sense of realism other people in the pictures wore modern, everyday clothes.

Portraits were for the most part dispassionate and objective. Although some

were commissioned, many are of the artist himself and of his family. A model may be shown posing in a studio surrounded by a number of the artist's friends.

Landscapes

Artists painting out of doors became increasingly aware of the different light effects caused by the changes in the weather.

This is particularly noticeable in the work of artists who painted in the forest of Fontainebleau and of others who chose the Channel ports as settings.

These artists' observations were recorded in numerous detailed preparatory drawings. A problem which they faced was that of how to convey much of this detail without allowing it to become too distracting. One solution found was that of chiaroscuro. For example, part of a building will be brightly lit while the rest is in transparent shadow.

Not until the Impressionists evolved their own methods of painting did most artists dispense with the preliminary sketch of outdoor scenes.

COROT *Avray village showing the Cabassud houses*

BOUDIN *The port of trade, Le Havre*

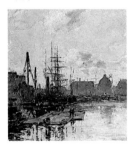

RUSSIA

In Russia a number of artists, inspired mainly by German Romantic painters and other Realist artists in Europe, were determined to create a new Russian culture. For them the presentation of a peasant or worker as a heroic figure was a novelty.

The works these artists produced seem realistic in a rather traditional manner. Some of the most interesting were stage sets for plays or ballets.

NATURALISM

BAIL *Scullery maids* (detail below)

In retrospect the differences between Realism and Naturalism may not seem great, but as early as 1863 writers in France accepted that there was a distinction between the two, the term 'Naturalists' being applied to the younger generation of Realists.

In many of their pictures the artists conveyed the life of the poor and the outcast in the big cities. Violent exception was taken to some of their paintings, particularly those in which labourers were seen neglecting their duties to engage in a little illicit love-making or a brief celebration.

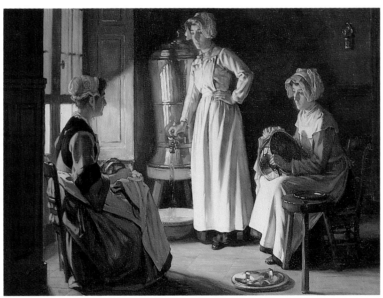

IMPRESSIONISM

Impressionism was a revolutionary kind of painting which emerged in France in the second half of the 19th century.

Earlier painters had worked in their studios and painted outdoor scenes from memory and

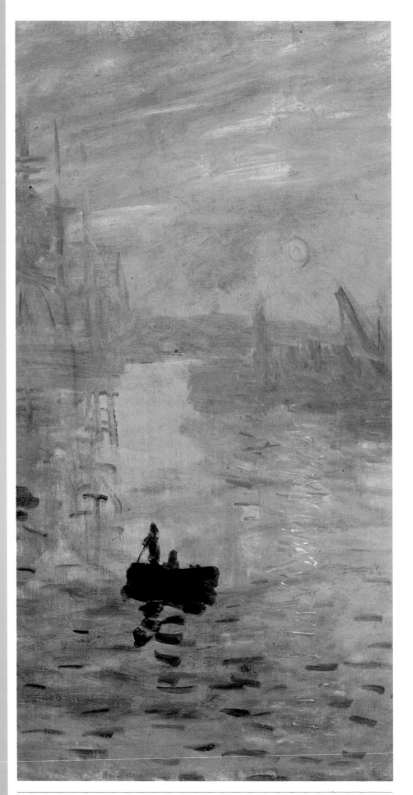

sketches. The Impressionists were among the first to take their easels out of doors and paint immediately what they saw.

As a result they painted objects – a tree, a mountain, a cornfield – not as their minds told them these objects should look, but as they appeared to the eye in a particular light at a particular time of day.

Green foliage seen from a distance would appear as blue. Shadows were not simply dark grey or brown but could take on some of the colours of their surroundings. The outline of a mountain seen against a clear sky lost its solidity.

The effect is almost as if the painters had added an extra dimension to reality.

The main concern of the Impressionists was with every aspect of light out of doors. They were helped by three important new developments. The first of these was the camera.

A number of the Impressionists made a practice of carrying their cameras with them. They used their photographs to study arrested movement and objects and landscapes when viewed from unusual angles.

No less important than the camera was the production of easily transportable tubes of paint.

Up until then, artists had had to mix their paints on their palettes before applying them to canvas. The Impressionists were freed from this physical restriction.

The third valuable technical development resulted from certain researches in optics. These were carried out by a French chemist, Eugène Chevreul, who showed how optical illusions could be created by placing certain colours next to each other.

Glowing, vibrant colours are characteristic of Impressionist paintings.

If you look closely at many Impressionist paintings you can see the brushwork too clearly. Step back two or three metres and the shapes will become solid and the structure of the picture clear.

MONET *Impression: sunrise*
(detail opposite and below)

Impressionist painting was too revolutionary to be accepted easily. Indeed, so many good paintings were at one time rejected by the official French Salon that an exhibition of them was staged in the so-called 'Salon des Refusés'.

A number of Impressionists were represented in the Salon des Refusés, and they duly formed their own group. The term 'Impressionist' was coined by a French journalist with reference to a picture by **Monet**, entitled *Impression: Soleil levant*, when referring in a derisory manner to the work of the group.

MONET *Impression: sunrise*

Today the best-known Impressionist paintings change hands for many millions of dollars and are regarded as 'investments'.

After a time, some of the best of the Impressionist painters broke away from the group and developed their own markedly individual styles.

SYMBOLISM

Symbolism was to some extent a reaction against the Impressionists, in particular against what some artists considered their excessive naturalism. This, in the opinion of one artist, excluded all 'thought, inspiration and fantasy' and offered nothing to those who wanted to 'explore the depths of the soul'.

Many Symbolists started as Sunday painters. Some continued as such. Others gave up a

steady source of income to concentrate on painting, suffering impoverishment as a consequence.

Symbolists were influenced by the bright palettes of the Impressionists but they tended to disregard perspective and to flatten form. Bright, flat areas of colour, strongly coloured outlines (often dark blues), a lack of shadows –

GAUGUIN *The vision after the sermon* (detail)

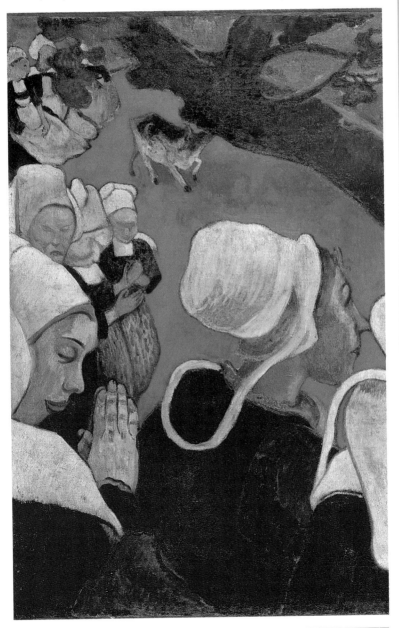

or a rather arbitrary choice of where they are placed – all heighten the decorative effect. The general appearance is sometimes like that of stained glass.

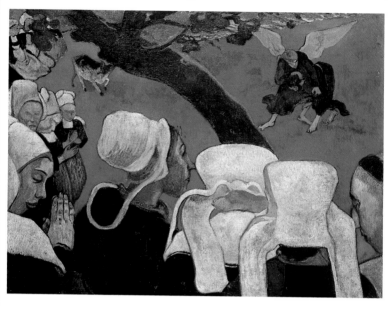

GAUGUIN *The vision after the sermon*

Some artists were attracted by exotic settings, such as Martinique and Tahiti, and their paintings were commentaries on the corrupting effects of civilization on primitive peoples.

Others deliberately chose a primitive, even amateurish style of painting. A family portrait will consist of stiffly jointed, doll-like figures with, as a background, a house whose prominent shutters strongly suggest the way a child paints.

The Symbolists did not ignore nature, but transformed it to fit the concepts of their own imagination. One artist's early work has a hallucinatory quality. This gives way after a time to his creation of a world of fabulous beasts and flowers drenched in light.

There were also Symbolists whose work at first sight appears academic in its precision of form, minutely recorded detail and bright, jewel-like colours, but their subjects tended to be macabre – e.g. Salome's joyous dance on learning of the death of John the Baptist.

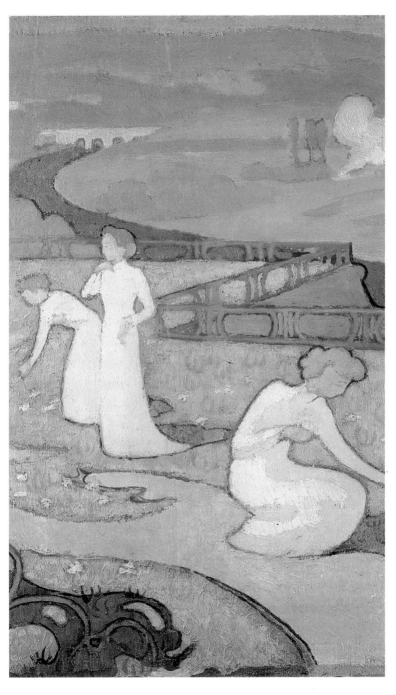

DENIS *April* (detail)

One group of Symbolists took for themselves the name **'Nabis'** – the Hebrew word for prophet. In their use of delicate, pale colours they looked back to Italian primitives before the time of Raphael.

Their range of subjects was wide, including portraits and figures in landscapes. Some of these figures seem to drift across the scene in a dream-like manner.

POST-IMPRESSIONISM

Post-Impressionism was a term coined for an exhibition in London in 1910 of the work of some artists who were dissatisfied with certain aspects of Impressionism. It was not a word which the artists themselves used.

The painters whom we have come to know as Post-Impressionists were admirers of the acknowledged great masters, particularly of the Renaissance. Some of them had close links with Impressionists, exhibited alongside them, and acknowledged their innovations in the use of light and colour.

In practice, colour was used by the Post-Impressionists as a means of modelling and expressing the structure of objects. Not surprisingly, those who lived and worked in the south of France used strong colours. One described what he saw around him as 'red roofs over blue sea'. The sun was so strong that it silhouetted objects not only in black and white, but in colour.

Post-Impressionist artists depicted a wide range of subjects from contemporary life. These included the theatre, ballet, race meetings and cafés. Such subjects had been treated by some of the Impressionists, but now there was a stronger element of social comment, as well as wit.

The apparent spontaneity of such works sometimes disguised the fact that many of them were produced in studios from sketches. The *pentimenti* (alterations of mistakes) are witness to the care with which they were executed.

The influence of Japanese prints is sometimes apparent. So is that of photography. Many of the Post-Impressionists

DEGAS *At the café (L'Absinthe)* (detail)

CEZANNE *Lac d'Annecy* (detail opposite)

CÉZANNE *Lac d'Annecy (detail)*

were keen photographers, and this helps to account for their unusual viewpoints, off-centre compositions and use of blank spaces. Again there is often a deceptive impression that the composition was unplanned.

Some painters also worked as sculptors and experimented with different media, such as gouache, egg tempera and pastel, as well as prints.

Others wrote of the expressive qualities of colour. One of the relatively few who was not himself a Frenchman once said: 'What a mistake the Parisians make in not having a palette for crude objects.'

Many of the paintings have **Expressionistic** characteristics. These are reinforced by violent, broken brushwork and thickly textured paint, indicative in some cases of a mood of despair.

NEO-IMPRESSIONISM

The term 'Neo-Impressionist' is sometimes applied to certain artists who had a quasi-scientific method of applying paint. This consisted of breaking down the colours into primaries and then applying the paint in dots or very small strokes. This method, known as **pointillism,** would, it was thought, achieve greater brightness. A further aim was to make figures solid without resorting to the more traditional methods of draughtsmanship.

In fact, the method imposed limitations with which the artists had to come to terms. Some abandoned the method or applied their theories sparingly.

SEURAT *The circus*

Chronology

1903	The Wright brothers make the first flight in an aircraft
1904	The Russo-Japanese War
1914	Henry Ford begins mass production of the Model 'T' Ford car
1914	Outbreak of World War I
1917	Start of the Russian Revolution
1918	End of World War I
1929	Czechoslovakia and Yugoslavia established as new countries
1924	The death of Lenin
1926	Television is first successfully demonstrated in Britain
1929	Alexander Fleming discovers penicillin
1933	Hitler becomes the German Chancellor
1937	The Japanese invasion of China
1939	The outbreak of World War II
1942	Nuclear chain reaction produced in Chicago by Enrico Fermi
1944	The production of the first digital computer
1945	End of World War II
1947	India and Pakistan become independent republics
1956	Soviet forces crush the uprising in Hungary
1957	The Treaty of Rome establishes the European Economic Community
1966	The Cultural Revolution begins in China

THE TWENTIETH CENTURY

The 20th century saw the greatest revolution in the history of Western painting.

Artists freed themselves from the restrictions of traditional painting and set themselves aims which had never been attempted before.

Leading painters became absorbed with such problems as how to represent the subconscious and the metaphysical, speed and violent emotions.

From this followed the development of **abstract art**, in which form, line and colour were used independently of any subject matter.

Much of the work of leading 20th-century artists was experimental, and new movements were formed, dissolved and re-formed in rapid succession. Painters frequently moved

PICASSO *The three dancers*

127

from group to group, and there was much interchange of ideas which is often reflected in the paintings.

Some of the groups issued manifestos to explain their aims to the general public. These are revealing and interesting documents; extracts from them are included in the following pages.

FAUVISM

The word 'Fauvism' was coined by a critic in Paris to describe the work of a group of painters. He thought the paintings looked as if they had been created by 'les fauves', i.e. the wild ones.

The form of the paintings was realistic, and the subjects were drawn from everyday life, including portraits, landscapes and interiors.

The paintings were exuberant in style and joyful in treatment. What earned them the name of 'fauve' was the choice of colours.

DE VLAMINCK *Paysage au Bois Mort*

DE VLAMINCK *Paysage au Bois Mort* (detail)

MATISSE *Riffian standing*

Broad areas of brilliant colours dominate the paintings. Clashing colours are placed next to each other. The colours are so vivid and so alive that they seem to have an existence which is independent of the picture.

Many of the painters worked **"alla prima."** That is to say they painted their pictures straight on to the canvas without any preliminary work, such as putting outlines on the canvas or making drawings.

Most of them painted quickly and did not bother with fine details. Pigment was often

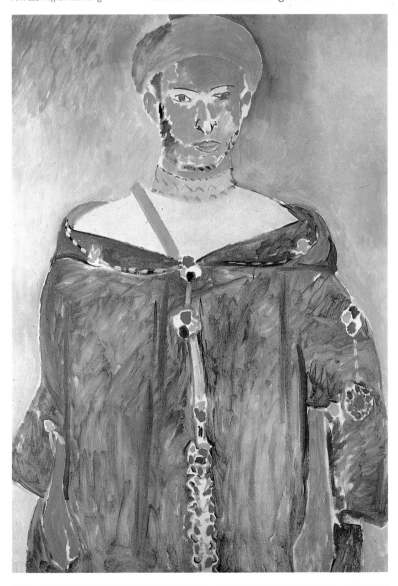

squeezed directly on to the canvas and finished with flamboyant, loose brushstrokes.

As a result Fauvist paintings have their own characteristic quality of spontaneity.

In Fauvist painting the colours are clearly not naturalistic. Here a broad band of green runs from the hairline down to the chin. The two sides of the face have different colours. The hair is a brilliant blue.

CUBISM

PICASSO *The three women*

Cubism was probably the most important and certainly the most influential movement in modern art. It can be said that Cubism created a new dimension to painting.

Traditional painters looked at an object from one particular angle and painted what they saw. Cubist painters, by contrast, believed that to give a true representation of an object you have to show it from more than one angle.

If they decided to paint a musical instrument they wanted to show what the instrument looked like, not only from the front, but also from each of the other three sides.

PICASSO *Instruments of music*

As the painter could not see all the different facets of the instrument at once he had to rely on his memory.

In other words, the conventional painter will paint what he sees, while the Cubist painted what he knew to be there.

The traditional method is known as perceptual painting, the Cubist as conceptual painting.

There is much truth in Cubist reasoning. If you close your eyes and try to remember what a particular object looks like, you may well find that you recall it as if seen simultaneously from different angles.

To be able to paint an object in this way the Cubists had to invent a new technique.

One way to explain this technique would be to say that the object was dismantled in the artist's mind into a number of geometric planes. Each plane represented a different facet of that object.

The painter would then rearrange these planes so that they formed a unified object in his picture.

The first period in Cubist painting was called **Analytical Cubism** and was mainly a time of experiment.

To the painter the experiment itself – the analysis of form – was of paramount importance. If the subject matter became hardly recognizable in the process this was not considered detrimental to the picture.

Form is created by superimposed, overlapping and interlocking geometric planes. There is no perspective, and only some very shallow depth is created by shading parts of the painting. Colours are mainly metallic blues and greys. There is no suggestion of air or atmosphere, and no light illuminating the picture as a whole. Light comes separately from individual parts and gives the paintings a kind of metallic glow.

The second phase, **Synthetic Cubism**, brought back a degree of realism, albeit distorted or abstracted realism.

First, various materials in everyday use, such

as a small piece of rough canvas or printed paper, were added to the paintings. The technique involved was known as **collage**.

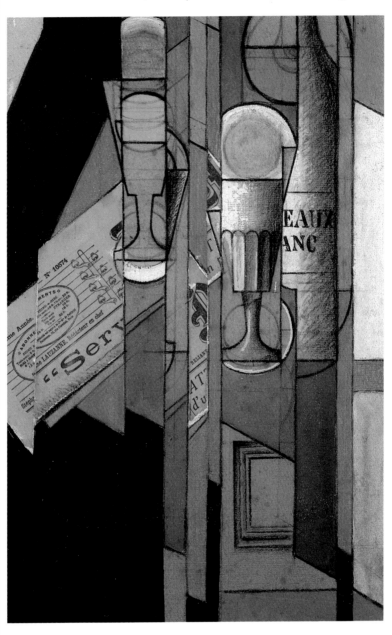

GRIS *Verres, journal et bouteille de vin* collage

Later the painters reintroduced colour and, to a certain extent, recognizable forms. In doing this they did not aim to copy nature, but rather to use the objects selected as a springboard for their own imagination.

FUTURISM

'We declare that the magnificence of the world has been enriched by a new beauty, the beauty of speed. A racing car with its bonnet draped in enormous pipes like fire-spitting serpents...a roaring racing car that goes like a machine gun is more beautiful than the Winged Victory of Samothrace.' *Extract from the Futurist Manifesto, published in 1909.*

BOCCIONI *The city rises*

The main preoccupation of the Futurists was with speed, movement and energy. Their concern was to translate these on to canvas.

They chose their subjects from everyday life and showed them either in motion or as seen from a moving object.

In a street scene people are running in different directions. Horses are galloping. Machinery is in motion.

Cars are driven at speed. A violinist's fingers are moving across his instrument.

To achieve these effects the Futurists often adapted the principles of multiple exposure photography.

In this, each exposure shows a different stage in the same movement. If these pictures are then placed next to each other so that they partially overlap an illusion of real movement is created – not unlike the early movies.

ORPHISM

The style of the early Orphists was a simplified form of Cubism combined with the use of very bright colours.

Painters became preoccupied with the representation of movement which they expressed through swirling concentric bands of colour. Aircraft and the Eiffel Tower are often visible in the background.

Their style later became more abstract, but their paintings lost none of their characteristic strong colours and luminosity.

DADAISM

'Dada began not as an art form, but as a disgust'

The word 'dada' means a hobby-horse in French.

Dadaism grew out of the despair felt by many artists at the senseless slaughter of World War I. As a movement it gained some international popularity among painters, sculptors and poets.

The Dadaists rejected all traditional art and culture, which they held to have been created by the kind of man who had made the horrors of the war possible. To replace it they offered what they themselves described as 'sheer nonsense'.

They invented what they called 'ready-mades', that is to say useless, discarded objects presented in a parody of high art. An example was the man's urinal turned upside down and signed 'R.Mutt'.

Chance dictated much of what was finally used. Torn pieces of paper were dropped on to a canvas. The random pattern they formed was the end result.

ARP *Composition*

One Dadaist painted a copy of the Mona Lisa with a moustache.

A number of the artists possessed real talent, and when the movement faded after a few years they turned to more positive art forms with considerable success.

RAYONNISM

Rayonnist painters tried to convey on canvas the essence of some of the scientific theories that were prevalent shortly before World War I. Among those in which they were particularly interested were Einstein's theories of space, time and relativity.

Many of their paintings depicted light rays seen in movement.

Some of the paintings are a shimmering grey, white or silver. Later brighter colours were also used.

The influence of Cubism on Rayonnist paintings is clearly noticeable.

GONCHAROVA *Spanish woman*

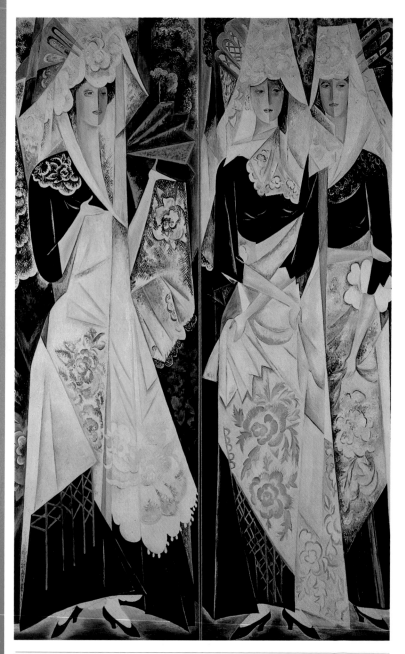

NEO-PLASTICISM

Neo-Plasticism is almost exclusively the work of artists from the Netherlands.

The paintings consist predominantly of horizontal and vertical black lines crossing each other, with coloured squares in between. In some paintings there are no black lines, but the coloured squares are still laid down in a grid system.

The pictures are completely two-dimensional without any depth or shading. The painters used only five colours: black, white, yellow, blue and red.

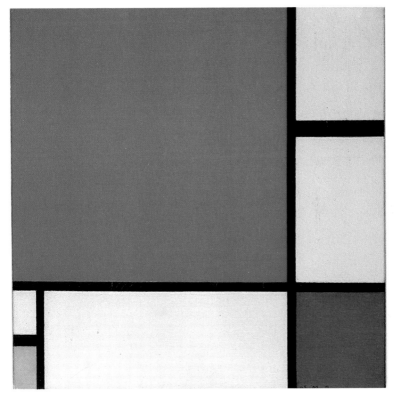

MONDRIAN *Composition in red, blue and yellow*

The vertical lines represent the male and the horizontal the female. The aim of the artists was to create harmony and balance between the two elements and so throughout the picture as a whole.

EXPRESSIONISM

'Expression, to my way of thinking, does not consist of the passion mirrored upon a human face or betrayed by a violent gesture. The whole arrangement of my picture is expressive. The place occupied by figures or objects, the empty spaces around them, the proportions – everything plays a part.'

– *Matisse*

MUNCH *The scream*

Expressionist painters proclaimed that the only acceptable aim of art is to represent emotions and feelings. Subject matter, colour, line, composition and technique must all be subjugated to the fulfilment of this purpose.

Expressionism flourished mainly in northern Europe, especially in Germany.

The paintings are representational, but the subject matter was chosen purely on the grounds of its suitability for expressing a particular emotion. In practice, landscapes, figures and figure groups were all frequently depicted.

In order to express their emotions more forcibly the artists often distorted figures and objects. Some painters outlined forms in black to create a sense of despair or *Angst*.

In some compositions the sharp, angular forms and clashing colours are almost suggestive of hysteria – even the paint seems to be slashed on to the canvas.

All the lines lead towards the focal point in the print – the head of a woman screaming. The whole of the scenery seems to share her emotion. The face and figure are distorted as in a caricature.

Many of the Expressionist pictures were woodcuts and as such were particularly suitable for the jagged, strong lines so often used.

KANDINSKY *Woodcut from Der Blaue Reiter*

SURREALISM

Surrealist painters looked largely to the subconscious for their inspiration. Never before had this been the deliberate policy of a school or group of painters.

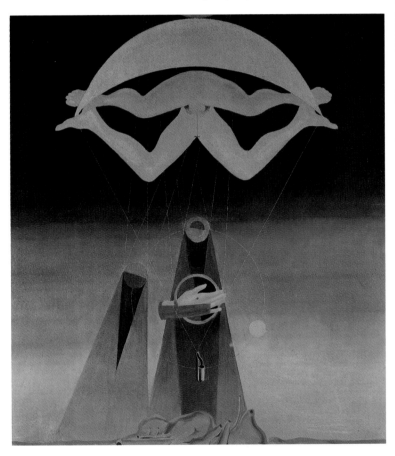

ERNST *Men shall know nothing of this, 1923*

A major influence was Sigmund Freud's *The Interpretation of Dreams*, published in 1900. Some Surrealist paintings were actually based on Freud's case-histories. In others the artists drew on their own dreams, fears and anxieties.

Now, for the first time, artists decided that there need be no restrictions on subject matter. Sexual desire and sexual fantasy could be presented as the artist wished. Violence, death and war were also common themes.

There were two main styles of Surrealist painting, the natural and the abstract.

In the first, individual objects are presented with total realism and in meticulous detail. But the setting, as in a dream, is often totally incongruous. So a fried egg may be seen hanging on a tree, or a cup and saucer may be covered with fur.

As in dreams, particular objects are singled out while the remainder of the furniture of a room or the features of a landscape are omitted.

In the second, the treatment is more abstract. Floating shapes rather than recognizable objects are seen. These are often suggestive of sex or of death, and they too can be seen against unexpected backgrounds.

Traditional oil painting is common in Surrealist work, but more experimental methods were also used.

For example, for parts of their pictures some artists mixed sand with the pigment to create interesting surfaces.

A new technique called **frottage** was used. The principle is that of a brass rubbing. The artist made a rubbing from the bark of a tree or from a stone, using a soft pencil and paper. He then cut the paper into shapes and stuck these shapes on to the canvas to suggest rocks or houses with a strange, ghost-like quality.

Another technique was called **grattage**. The canvas was covered with random drips and splashes of paint; this process was repeated in a number of layers and in various colours. After

DALI *Lobster telephone*

the paint had dried the painter scraped parts of it off, leaving a multi-coloured and often intriguing result.

Sometimes several of the Surrealists' techniques were applied to the same painting. It can be amusing to play the detective by trying to unravel the sequence of those used.

Surrealist paintings can appeal at two levels: through the beauty of the objects represented and because they tell us something which we too may have felt deep down.

By the conjunction of the recognizable with the improbable they can give us a tremor of excitement. They can shock. They can also at times be very funny.

ABSTRACT ART

The term 'abstract' is applied to paintings which have no recognizable subject matter.

The German philosopher Schopenhauer wrote that 'all the arts aspire to the conditions of music'.

Music – which is non-representational – affects us both emotionally and intellectually. Abstract artists believed that the same principle applies to other art forms. What really affects us in a painting is not, they considered, the copy of a recognizable object on the canvas, but shape, colour, texture and line.

For example, the juxtaposition of colours such as shocking pink and scarlet can clash in much the same way as sounds do.

Abstract artists argued further that if recognizable subject matter is not necessary for the enjoyment of paintings, it can simply be left out.

Shape, colour, texture and line will then be presented, as in music, in a carefully composed work.

A picture may show nothing but a single black square on a plain white background. But for the artist to achieve the effect he was aiming at the

ALBERS *Study of Homage to the Square, blue climate*

square had to be exactly the right size and placed at exactly the right angle in relation to the background.

Kandinsky, one of the greatest abstract painters, declared that an acute-angled triangle of a particular size, shape, colour and texture, touching the circumference of a circle of a particular size, shape, colour and texture, could have as great an effect on the viewer as the finger of God touching Adam on the ceiling of the Sistine Chapel.

There is great variety in abstract painting. Some painters show mainly geometric forms, such as rectangles, squares, triangles or circles, either looking as if they are lying flat on the canvas or creating the illusion of projecting from it.

Others use irregular forms and organic shapes or cover the whole canvas with splashes and drips of paint.

Abstract art is for contemplation. Everyone can interpret the pictures in his or her own individual way.

ABSTRACT EXPRESSIONISM

Abstract Expressionism was primarily an American phenomenon of the years shortly after World War II.

Painters saw themselves as expressing either their own innermost feelings or the collective unconscious.

Their pictures are massive, and their methods of applying paint highly individual. Some dispensed with oil paint, using household paint instead.

One artist, for example, would unroll a length of canvas and tack it to the floor. He would then go round it, carrying a large bucket of paint and a brush. At some stage, moving as if in a trance, he would walk across the canvas, dripping and spattering paint until a labyrinth of lines appeared. Sometimes he would wheel a tricycle dipped in paint across it. At a certain

POLLOCK *Full fathom five*

moment, which only he could judge, he felt that the painting was finished.

Another artist would cover a wall of canvas in one colour and then divide parts of it with stripes of another colour.

The Abstract Expressionists graduated from being conventional painters. They did not all

DE KOONING *Marilyn Monroe*

143

eschew the human figure, but such figures as are seen tend to be grotesquely, even hideously distorted.

Several of these artists led unhappy lives, and more than one committed suicide.

OP ART

VASARELY *Supernovae*

Op Art, a movement which began in the mid-1950s, exploited the possibilities of optical illusion in new and exciting ways.

Artists have been creating optical illusions since they first started to practise. Such illusions serve, for example, to make foreshortening convincing. One of the novelties in Op Art lay in the way in which abstract images were used to give an illusion of movement.

One example of this was a huge chequerboard, in which the squares were carefully distorted and their sizes varied. Not only do the squares seem to move, but their alignment seems now diagonal, now vertical, now horizontal.

Op Art pictures are particularly impressive when they cover large surfaces, for example the different walls of a room.

POP ART

Pop Art is both a return to representational painting and an expression of revolt against earlier aesthetic standards.

Pop artists had in common what one of them called a 'vernacular culture'. Others have called it a 'coke culture'. Inspiration comes from comic strips, advertisement hoardings, pop music posters, soup tins, labels and other everyday objects associated with mass consumption.

Techniques used are appropriate to the objects depicted. Flags painted in stark, unmodified colours, stencilled letters, writing on packing cases, quasi-photographic representation are among them. Surfaces are often bright and shiny.

Much of Pop Art takes the form of parody, and at its best it is extremely witty. It is also at times highly critical of society. But the fashions and cults it presents, and to some extent satirizes, are inevitably transitory.

WARHOL *Campbell's soup*

BIBLIOGRAPHY

Bowness, A. (1972) *Modern European Art.* Thames and Hudson.
Collingwood, R. G. (1938) *The Principles of Art.* Clarendon Press.
Dodwell, C. R. (1971) *Painting in Europe 800-1200* Penguin Books.
Gombrich, E. H. (1950) *The Story of Art.* Phaidon.
Hiler, H. (1969) *Notes on the Technique of Painting.* Faber and Faber.
Mayer, R. (Smith, E., ed.) (1975) *The Artist's Handbook.* Faber Paperbacks.
Murray, P. and **Murray, L.** (1963) *The Art of the Renaissance.* Thames and Hudson.

Glossary

ACRYLIC	A quick-drying paint developed in the mid-20th century which helps to give an impression of transparency.
ALLA PRIMA	A 19th-century term for the work of painters who completed the surface of their picture in one session without making any preliminary drawings.
AQUATINT	A kind of etching whose appearance resembles drawing in watercolours or Indian ink.
ARABESQUE	Surface decoration consisting of geometric patterns and plant forms but lacking human figures.
ATTRIBUTION	An authoritative judgement (which may not necessarily be correct) that a picture is the work of a particular artist.
BIEDERMEIER	A term applied mainly to furniture and decorations, but also to painting and sculpture, to denote work produced in the first half of the 19th century in Germany. The work, which was simple in style, was also thought to be bourgeois and somewhat philistine.
BITUMEN	A brown pigment much used in the 18th and 19th centuries, which has in fact destroyed a number of pictures, for it never dries completely.
BLOCK-BOOK	An early kind of illustrated book, in which illustrations and text were cut from the same block.
BOTTEGA	An Italian term for an artist's workshop or studio.
CALLIGRAPHY	A word normally used to mean the art of handwriting, but also applied to the free brushwork of painters.

CAMEO	A stone or shell of different coloured layers cut in relief.
CAMERA OBSCURA	A 16th-century invention consisting of mirrors and lenses in a darkened tent or a box. The view seen through the lens was reflected back on to a sheet of paper so that the artist could trace round it to achieve an accurate representation of the subject.
CARTOON	Originally a full-sized drawing for a painting, often one which could be transferred immediately to a wall or canvas. In modern usage a satirical or comic drawing.
CHIAROSCURO	A term meaning light and dark which is used to indicate the way in which a painter balances light and shade to achieve his effects. Normally applied to paintings with predominantly dark tones.
CINQUECENTO	The Italian word for five hundred, which is used to mean the 16th century.
COLLAGE	A picture built up by sticking pieces of paper and other materials, such as cloth, on to a canvas. The method became fashionable in certain 20th-century schools of art.
FRESCO	A method of painting on walls in which the pigment is mixed with water and then applied to a wall which has just been plastered.
GENRE	A kind of painting, usually small in size, which shows objects of everyday use in a realistic and in no way idealized manner.
GENRES	Different categories of painting, such as portraits, landscapes and still-lifes.
GOUACHE	A kind of opaque watercolour paint also known as poster paint.
GROTESQUE	A word normally meaning fantastic or extravagant, but in art applied to decorative ornamentation which differs from arabesque in that it may include representation of human and animal figures.
GROUND	The surface on which a painting is executed.

HISTORY PAINTING	A term sometimes applied to paintings of biblical or mythological scenes as well as ancient historical events.
IMPASTO	Oil paint which has been applied thickly.
LOCAL COLOUR	A term used by artists to define the colour of an object when seen from a very short distance, as opposed to the colour it takes on when seen from further away.
MAESTÀ	The Italian word for majesty, applied to pictures in which the Madonna and Child are shown enthroned and surrounded by saints or angels.
MANDORLA	The light, in the shape of an almond, which in early religious pictures surrounds Christ or the Virgin Mary.
MONTAGE	A picture created by cutting out and then mounting prints, photographs and other objects on a canvas or other surface.
PAINTERLY	A translation of the German word *malerisch*, which is used to describe works in which forms are created by painting and by light and shade rather than by linear drawing.
PASTEL	A mixture of dry powdered colour with some gum which serves to bind it.
PICTURE PLANE	The front of the imaginary space which any picture creates – i.e. that part which is nearest the viewer.
POLYPTYCH	A painting, usually an altarpiece, of more than three panels.
PRIMING	The first coating applied to a surface which is to be painted on.
PUTTO	A small, often naked male child.
REPRESENTATIONAL	The kind of art (as opposed to abstract) in which objects are depicted in clearly recognizable form.
SCUMBLING	The application of one layer of opaque or nearly opaque oil paint on top of another so that the lower layer is only partly concealed.

SFUMATO	A gradual transition from one colour to another or from light to shade which may be achieved in oil painting by the use of glazes.
SKETCH	A preliminary study for a painting or a rough drawing showing its main features.
STILL-LIFE	A picture of inanimate objects.
TEMPERA	A mixture of egg-yolk with either oil or water which is used in painting.
WATERCOLOUR	The mixture of pigments with water as opposed to oil.

Compendium of Artists

This compendium has been compiled in order to provide basic information about over 500 artists. For further general information, find the 'style' listed for any particular artist in the compendium. Look for this 'style' in the index. It will tell you which pages of the main text contain information relevant to this artist.

c. = about C = century d. = died *fl.* = active from

	NAME AND NATIONALITY	STYLE	SCHOOL
A	ABBATE, Niccole dell 1512–71 (Italian)	Mannerism	Italian
	AERTSEN, Pieter 1508–75 (Flemish)	High Renaissance	Flemish
	AFRO, Bogadell 1912–76 (Italian)	Abstract	—
	ALTDORFER, Albrecht 1480–1538 (German)	Mannerism	German
	ALTICHIERO c.1330–c.1395 (Italian)	International Gothic	Italian
	AMIGONI, Jacopo c.1682–1752 (Italian)	Rococo	Italian
	AMMANNATI, Bartolomeo 1511–92 (Italian)	Mannerism	Italian
	ANDREA del Sarto 1486–1530 (Italian)	High Renaissance	Florentine
	ANGELICO, Fra c.1400–55 (Italian)	Early Renaissance	Florentine
	ANTONELLO da Messina 1430–79 (Italian)	Renaissance	Florentine
	APPEL, Karel 1921– (Dutch)	Abstract Expressionism	—
	APPIANI, Andrea 1754–1817 (Italian)	Neo classical	Italian
	APT, Ulrich the Elder c.1465–1532 (German)	High Renaissance	German
	ARCHIPENKO, Alexander 1887–1964 (Russian)	Cubism	—
	ARCIMBOLDO, Giuseppi 1527–93 (Italian)	Mannerism	Italian
	ARP, Jean 1887–1966 (French)	Dadaism	—
	ARPINO, Giuseppe 1568–1640 (Italian)	Mannerism	Italian

NAME AND NATIONALITY	STYLE	SCHOOL
ASAM, Cosmas Damian 1686–1739 (German)	Baroque	German
B BACICCIO, Giovanni 1639–1709 (Italian)	Baroque	Italian
BACON, Francis 1909– (English)	Expressionism	British
BAIL, Joseph 1862–1921 (French)	Naturalism	—
BALDOVINETTI, Alesso 1426–99 (Italian)	Renaissance	Florentine
BALDUNG, Hans 1484–1545 (German)	High Renaissance	German
BALL, Hugo 1886–1927 (Swiss)	Dadaism	—
BANDINELLI, Baccio 1493–1560 (Italian)	High Renaissance	Florentine
BARLACH, Ernst 1870–1938 (German)	Expressionism	—
BAROCCIO, Federico 1535–1612 (Italian)	Mannerism	Italian
BARRY, James 1741–1806 (Irish)	Grand Manner	British
BARTOLOMMEO della Porta 1472–1517 (Italian)	High Renaissance	Florentine
BASSANO, Jacopo 1510–92 (Italian)	High Renaissance	Venetian
BASSANO, Francesco 1549–92 (Italian)	High Renaissance	Venetian
BASSANO, Leandre 1557–1622 (Italian)	High Renaissance	Venetian
BASTIEN-LEPAGE, Jules 1848–84 (French)	Realism	French
BATONI, Pompeo 1708–87 (Italian)	Rococo	Italian
BAUMEISTER, Willi 1889–1955 (German)	Abstract	—
BAZILLE, Frédéric 1841–71 (French)	Impressionism	French
BEAUMONT, Claudio Francisco 1694–1766 (French)	Rococo	French
BEARDSLEY, Aubrey 1872–98 (English)	Art Nouveau	British
BECCAFUMI, Domenico 1484–1551 (Italian)	Mannerism	Italian
BECKMANN, Max 1884–1950 (German)	Expressionism	—
BELLINI, Jacopo 1400–70 (Italian)	Renaissance	Venetian

NAME AND NATIONALITY	STYLE	SCHOOL
BELLINI, Gentile 1430–1507 (Italian)	Renaissance	Venetian
BELLINI, Giovanni 1430–1516 (Italian)	High Renaissance	Venetian
BELLOTTO, Bernardo 1721–80 (Italian)	Neoclassical	Italian
BERCHEM, Nicolaes 1620–83 (Dutch)	Baroque	Dutch
BERLINGHIERO 1215–42 (Italian)	Medieval	Italian
BERNINI, Gianlorenzo 1598–1680 (Italian)	Baroque	Italian

BERNINI *Ecstasy of St Teresa*
(detail left)

BLAKE *Satan, Sin and Death*
(detail right)

NAME AND NATIONALITY	STYLE	SCHOOL
BLAKE, William 1757–1827 (English)	Romanticism	English
BLOEMART, Abraham 1564–51 (Dutch)	Mannerism	Dutch
BOCCIONI, Umberto 1882–1916 (Italian)	Futurism	—
BÖCKLIN, Arnold 1827–1901 (Swiss)	Romanticism	—
BOLTRAFFIO, Giovanni Antonio 1467–1516 (Italian)	High Renaissance	Italian
BONINGTON, Richard Parkes 1801–28 (English)	Romanticism	English
BONNET, Louis-Marin 1736–93 (French)	Rococo	French
BORDONE, Paris 1500–71 (Italian)	High Renaissance	Italian
BOSCH, Hieronymus 1450–1516 (German)	High Renaissance	German
BOTH, Andries 1608–41 (Dutch)	Baroque	Dutch
BOTH, Jan 1618–52 (Dutch)	Baroque	Dutch
BOTTICELLI, Sandro 1445–1510 (Italian)	Renaissance	Florentine
BOUCHER, François 1703–70 (French)	Rococo	French

NAME AND NATIONALITY	STYLE	SCHOOL
BOURDON, Sébastien 1616–71 (French)	Baroque	French
BOUTS, Dieric 1415–75 (Flemish)	Renaissance	Flemish
BRAMANTINO, Bartolomeo 1465–1530 (Italian)	High Renaissance	Italian
BRAQUE, Georges 1882–1963 (French)	Cubism	—
BRIL, Paul 1554–1626 (Flemish)	Baroque	Flemish
BROEDERLAM, Melchior 1381–1409 (French)	International Gothic	—
BRONZINO, Agnolo 1503–72 (Italian)	Mannerism	Florentine
BROUWER, Adriaen 1605–38 (Flemish)	Baroque	Flemish
BROWN, Ford Maddox 1821–93 (English)	Pre-Raphaelite	English
BRUEGEL, Jan 1568–1625 (Flemish)	High Renaissance	Flemish
BRUEGEL, Pieter 1525–69 (Flemish)	High Renaissance	Flemish
BRUEGEL, Pieter II 1564–1638 (Flemish)	High Renaissance	Flemish
BULLANT, Jean 1515–78 (French)	Mannerism	French
BURGKMAIR, Hans 1473–1531 (German)	High Renaissance	German
BURNE-JONES, Sir Edward 1833–98 (English)	Pre-Raphaelite	English
C CAILLEBOTTE, Gustave 1848–93 (French)	Impressionism	—
CALVERT, Edward 1799–1883 (English)	Romanticism	English
CAMPIN, Robert 1378–1444 (Flemish)	Renaissance	Flemish
CANALETTO, Antonio 1697–1768 (Italian)	Realism	Venetian
CAPPELLE, Jan van de 1624–79 (Dutch)	Baroque	Dutch
CARAVAGGIO, Michelangelo 1571–1610 (Italian)	Baroque	Italian
CARON, Antoine 1520–99 (Italian)	Mannerism	Italian
CARPACCIO, Vittore 1460/5–1523 (Italian)	High Renaissance	Venetian
CARRACCI, Ludovico 1555–1619 (Italian)	Mannerism	Italian

NAME AND NATIONALITY	STYLE	SCHOOL
CARRACCI, Agostino 1557–1602 (Italian)	Mannerism	Italian
CARRACCI, Annibale 1560–1609 (Italian)	High Renaissance	Italian
CASSATT, Mary 1844–1926 (American)	Impressionism	—
CASTAGNO, Andrea del 1421–57 (Italian)	Renaissance	Florentine
CAVALLINI, Pietro 1273–1308 (Italian)	Byzantine	Roman
CÉZANNE, Paul 1839–1906 (French)	Post-Impressionism	—
CHAGALL, Marc 1887–1986 (Russian)	Expressionism Surrealism	—
CHAPAIGNE, Philippe de 1602–74 (French)	Baroque	French
CHARDIN, Jean Baptiste 1699–1779 (French)	Rococo	French
CHARPENTIER 1728–1806 (French)	Rococo	French
CHIRICO, Giorgio de 1888–1978 (Italian)	Surrealism	—
CHRISTUS, Petrus d.1472/3 (Flemish)	Renaissance	Flemish
CIMABUE 1240–1302 (Italian)	Byzantine	Florentine

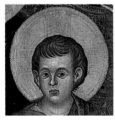

CIMABUE *The Virgin and Christ in majesty surrounded* (detail left)

LORRAIN *Pastoral landscape* (detail right)

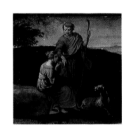

CLAUDE, Lorrain 1600–82 (French)	Baroque	French
CLOUET, François d.1572 (French)	Mannerism	Fontainebleau
COELLO, Claudio 1642–93 (Spanish)	Baroque	Spanish
COLLINSON, James 1825–81 (English)	Pre-Raphaelite	English
CONSTABLE, John 1776–1837 (English)	Landscapist (19th C)	British
CORINTH, Lovis 1858–1925 (German)	Impressionism	—

NAME AND NATIONALITY	STYLE	SCHOOL
CORNELIUS, Peter von 1783–67 (German)	Nazarene	—
COROT, Jean Baptiste Camille 1796–1875 (French)	Realism	French
CORREGGIO, Antonio 1489–1534 (Italian)	Mannerism	Italian
COSSA, Francesco del 1435–77 (Italian)	Renaissance	Italian
COTMAN, John 1782–1842 (English)	Landscapist (19th C)	British
COURBET, Gustave 1819–77 (French)	Realism	French
COYPEL, Charles Antoine 1694–1752 (French)	Rococo	French
CRANACH, Lucas I 1472–1553 (German)	High Renaissance	German
CRANACH, Lucas II 1515–86 (German)	High Renaissance	German
CREDI, Lorenzo di 1458–1537 (Italian)	High Renaissance	Florentine
CRESPI, Giovanni 1575–1632 (Italian)	Baroque	Florentine
CRIVELLI, Carlo d.1495/1500 (Italian)	Renaissance	Venetian
CUYP, Aelbert 1620–91 (Dutch)	Baroque	Dutch

D

NAME AND NATIONALITY	STYLE	SCHOOL
DADDI, Bernardo 1290–1349/51 (Italian)	Pre-Renaissance	Florentine
DALÍ, Salvador 1904–88 (Spanish)	Surrealism	—
DAUBIGNY, Charles 1817–78 (French)	Realism	French
DAUMIER, Honoré 1808–79 (French)	Realism	French
DAVID, Gerard d.1523 (Dutch)	Renaissance	Dutch
DAVID, Jacques Louis 1748–1825 (French)	Neoclassicism	French
DEGAS, Edgar 1834–1917 (French)	Impressionism	—
DELACROIX, Eugène 1798–1863 (French)	Romanticism	French
DELAUNAY, Robert 1885–1941 (French)	Orphism	—
DELAUNAY-TERK, Sonia 1885–1979 (French)	Orphism	—
DELVAUX, Paul 1897– (French)	Surrealism	—

NAME AND NATIONALITY	STYLE	SCHOOL
DENIS, Maurice 1870–1943 (French)	Symbolism	—
DERAIN, André 1880–1954 (French)	Fauvism	—
DEVIS, Arthur 1711–87 (English)	Portraiture in the Grand Manner	British
DIX, Otto 1891–1969 (German)	Expressionism	—
DOLCI, Carlo 1616–86 (Italian)	Baroque	Italian
DOMENICHINO 1581–1641 (Italian)	Baroque	Italian
DOMENICO, Veneziano d.1461 (Italian)	Renaissance	Florentine
DOSSI, Dosso 1479/90–1542 (Italian)	High Renaissance	Florentine
DOU, Gerard 1613–75 (Dutch)	Baroque	Dutch
DROUAIS, François 1727–75 (French)	Portraiture Neoclassicism	French
DUBUFFET, Jean 1901– (French)	Abstract Expressionism	—
DUCCIO di Buoninsegna 1255–1318 (Italian)	Medieval	Siennese
DUCEREAU, Jacques 1510–84 (French)	Mannerism	Fontainebleau
DUFY, Raoul 1877–1953 (French)	Fauvism	—
DU JARDIN, Karel 1622–78 (Dutch)	Baroque	—
DÜRER, Albrecht 1471–1528 (German)	High Renaissance	German
DYCE, William 1806–64 (English)	Pre-Raphaelite	English
DYCK, Sir Anthony van 1599–1641 (Dutch)	Baroque	Dutch
E ELSHEIMER, Adam 1578–1610 (German)	Baroque	German
ERNST, Max 1891–1976 (German)	Surrealism	—
EWORTH, Hans fl.1549–74 (Flemish)	High Renaissance	Flemish
EYCK, Jan van fl.1422–41 (Flemish)	Renaissance	Flemish
F FABRITIUS, Carel 1622–54 (Dutch)	Baroque	Dutch

NAME AND NATIONALITY	STYLE	SCHOOL
FANTIN-LATOUR, Henri 1836–1904 (French)	Impressionism	French
FEININGER, Lyonel 1871–1956 (German)	Cubism	—
FERRARI, Gaudenzio 1471/81–1546 (Italian)	High Renaissance	Italian
FETI, Domenico 1588/9–1623 (Italian)	Baroque	Italian
FONTAINEBLEAU, School of c.1560–1610 (French)	Mannerism	French
FOPPA, Vincenzo 1427/30–1515/16 (Italian)	Renaissance	Italian
FOUQUET, Jehan 1420–81 (French)	Renaissance	French
FRAGONARD, Jean Honoré 1732–1806 (French)	Rococo	French
FRANCIA, Francesco 1450–1517/18 (Italian)	High Renaissance	Italian
FRANCIABIGIO 1482/3–1525 (Italian)	High Renaissance	Florentine
FRANCIS, Sam 1923– (American)	Abstract Expressionism	—
FRENCH SCHOOL, The 16th C (French)	Mannerism	Fontainebleau

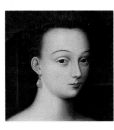

SCHOOL OF FONTAINEBLEAU *Gabrielle d'Este and her sister, the Duchess of Villars* (detail left)

FRIEDRICH *The cross in the mountains* (detail right)

FRIEDRICH, Casper David 1774–1840 (German)	Romanticism	German
FRITH, William Powell 1818–1909 (English)	Pre-Raphaelite	British
FUSELI, Henry 1741–1825 (Swiss)	Romanticism	—
G GADDI, Taddeo d.1366 (Italian)	International Gothic	Florentine
GAINSBOROUGH, Thomas 1727–88 (English)	Portraiture in the Grand Manner	English
GAUGUIN, Paul 1848–1903 (French)	Symbolism	—-
GEERTGEN, Tot Sint Jans (late 15th c) (Dutch)	Renaissance	Dutch

NAME AND NATIONALITY	STYLE	SCHOOL
GENTILE da Fabriano 1370–1427 (Italian)	International Gothic	Florentine
GENTILESCHI, Orazio 1563–1639 (Italian)	Baroque	Italian
GENTILESCHI, Artemisia 1597–1651/3 (Italian)	Baroque	Italian
GÉRARD, Baron François 1770–1837 (French)	Neoclassicism	French
GÉRICAULT, Théodore 1791–1824 (French)	Romanticism	French
GHIBERTI, Lorenzo 1378–1455 (Italian)	Renaissance	Florentine
GHIRLANDAIO, Domenico 1449–94 (Italian)	Renaissance	Florentine
GIAQUINTO, Corrado 1703–65 (Italian)	Rococo	Italian
GIORDANO, Luca 1632–1705 (Italian)	Baroque	Italian
GIORGIONE 1476/8–1510 (Italian)	High Renaissance	Venetian
GIOTTO 1276–1337 (Italian)	Pre-Renaissance	Florentine
GIOVANNI di Paolo 1403–82/3 (Italian)	Renaissance	Italian
GIRODET de Roucy-Trioson Anne-Louis 1767–1824 (French)	Romanticism	French
GIRTIN, Thomas 1775–1802 (English)	Landscapist Neoclassicism	English
GIULIO Romano 1492–1546 (Italian)	Mannerism	Italian
GLEIZES, Albert 1881–1953 (French)	Cubism	French
GOES, Hugo van der d.1482 (Flemish)	Renaissance	Flemish
GONCHAROVA, Natalya 1881–1962 (Russian)	Rayonism	—
GOGH, Vincent van 1853–90 (Dutch)	Impressionism	—
GOYA, Francisco de 1746–1828 (Spanish)	Rococo	Spanish
GOYEN, Jan van 1596–1656 (Dutch)	Baroque	Dutch
GOZZOLI, Benozzo 1421–97 (Italian)	Renaissance	Florentine
GRANACCI, Francesco 1470–1543 (Italian)	High Renaissance	Florentine

NAME AND NATIONALITY	STYLE	SCHOOL
EL GRECO (Domenikos Theotocopoulos) 1541–1614 (Spanish)	Baroque Mannerism	Spanish
GREUZE, Jean Baptiste 1725–1805 (French)	Rococo	French
GRIS, Juan 1887–1927 (Spanish)	Cubism	—

GRIS *Verres, journal et bouteille de vin* (detail left)

GROS *Napoleon Bonaparte visiting the plague-stricken* (detail right)

NAME AND NATIONALITY	STYLE	SCHOOL
GROS, Antoine Jean 1771–1835 (French)	Romanticism	French
GROSZ, George 1893–1959 (German)	Dadaism	—
GRÜNEWALD, Mathias 1470/80–1528 (German)	High Renaissance	German
GUARDI, Francesco 1712–93 (Italian)	Rococo	Italian
GUERCINO 1591–1666 (Italian)	Baroque	Italian

H

NAME AND NATIONALITY	STYLE	SCHOOL
HALS, Frans 1581/5–1666 (Dutch)	Baroque	Dutch
HAMILTON, William 1751–1801 (English)	Portraiture in the Grand Manner	English
HARTUNG, Hans 1904– (German)	Abstract	—
HAUSMANN, Raoul 1886–1971 (Austrian)	Dadaism	—
HEARTFIELD, John 1891–1968 (German)	Dadaism	—
HEEMSKERCK, Maerten van 1498–1574 (Dutch)	Mannerism	Dutch
HEYDEN, Jan van der 1637–1712 (Dutch)	Baroque	Dutch
HILLIARD, Nicholas 1547–1619 (English)	High Renaissance Portraiture	English
HOBBEMA, Meindert 1638–1709 (Dutch)	Baroque	Dutch
HOFER, Karl 1878–1955 (German)	Expressionism	—

NAME AND NATIONALITY	STYLE	SCHOOL
HOGARTH, William 1697–1764 (English)	Moralism	English
HOLBEIN, Hans the Elder 1465–1524 (German)	Renaissance	German
HOLBEIN, Hans the Younger 1497/8–1543 (German)	High Renaissance	German
HOLMAN-HUNT, William 1827–1920 (English)	Pre-Raphaelite	English
HONDECOETER, Melchior 1636–95 (Dutch)	Baroque	Dutch
HONTHORST, Gerard van 1590–1656 (Dutch)	Baroque	Dutch
HOOCH, Pieter de 1629–84 (Dutch)	Baroque	Dutch
HOOGSTRATEN, Samuel van 1627–78 (Dutch)	Baroque	Dutch
HUBER, Wolf c.1490–1553 (German)	Mannerism	German
HUET, Jean Baptiste 1745–1811 (French)	Rococo	French
HUGHES, Arthur 1832–1915 (English)	Pre-Raphaelite	English
I INGRES, Jean Auguste 1780–1867 (French)	Neoclassicism	French
ISENBRANDT, Adriaen d.1551 (Flemish)	High Renaissance	Flemish
J JANCO, Marcel 1895– (Romanian Israeli)	Dadaism	—
JAWLENSKY, Alexej von 1864–1941 (Russian)	Expressionism	—
JOHNS, Jasper 1930– (American)	Pop Art	—
JOOS VAN WASSENHOVE, (called Justus of Ghent) fl. c.1460–80 (Flemish)	Renaissance	Flemish
JORDAENS, Jacob 1593–1678 (Flemish)	Baroque	Flemish
K KANDINSKY, Wassily 1866–1944 (Russian)	Expressionism	—
KAUFFMANN, Angelica 1741–1807 (Swiss)	Neoclassicism	—
KIRCHNER, Ernst 1880–1938 (German)	Expressionism	—
KLEE, Paul 1879–1940 (Swiss)	Abstract	—
KLIMT, Gustav 1862–1918 (Austrian)	Symbolism	—

NAME AND NATIONALITY	STYLE	SCHOOL
KLINE, Franz 1910–62 (American)	Abstract Expressionism	—
KNELLER, Sir Godfrey 1646/49–1723 (German)	Baroque	German
KOCH, Joseph 1768–1839 (Austrian)	Neoclassicism	—
KOLLWITZ, Käthe 1867–1945 (German)	Expressionism	—
KOONING, Willem De 1904– (Dutch)	Abstract Expressionism	—
KOKOSCHKA, Oskar 1886–1980 (Austrian)	Expressionism	—
KONINCK, Philips de 1619–88 (Dutch)	Baroque	Dutch
KULMBACH, Hans von c.1480–1522 (German)	High Renaissance	German
L LANDSEER, Sir Edwin 1802–73 (English)	Naturalism	English
LANFRANCO, Giovanni 1582–1647 (Italian)	Baroque	Italian
LARGILLIERE, Nicholas de 1656–1746 (French)	Rococo	French
LARINOV, Mikhail 1881–1964 (Russian)	Rayonism	Russian
LASTMAN, Pieter 1583–1633 (Dutch)	Baroque	Dutch
LA TOUR, Georges de 1593–1652 (French)	Baroque	French
LAWRENCE, Sir Thomas 1769–1830 (English)	Portraiture in The Grand Manner	English
LEBRUN, Charles 1619–90 (French)	Baroque	French
LECK, Barth van der 1876–1939 (Dutch)	Neo-Plasticism	—
LÉGER, Fernand 1881–1955 (French)	Cubism	—
LEIBL, Wilhelm 1844–1900 (German)	Realism	German
LELY, Sir Peter 1618–80 (Dutch)	Baroque	Dutch
LEMOYNE, François 1688–1737 (French)	Rococo	French
LE NAIN, Antoine 1588–1648 (French)	Baroque	French
LE NAIN, Louis 1593–1648 (French)	Baroque	French
LE NAIN, Mattieu 1607–77 (French)	Baroque	French

NAME AND NATIONALITY	STYLE	SCHOOL
LEONARDO da Vinci 1452–1519 (Italian)	High Renaissance	Italian
LEWIS, Wyndham 1884–1957 (English)	Vorticism (Futurism)	—
LEYSTER, Judith 1609–60 (Dutch)	Baroque	Dutch
LICHTENSTEIN, Roy 1923– (American)	Pop Art	—
LIEBERMANN, Max 1847–1935 (German)	Impressionism	—
LIEVENS, Jan 1607–74 (Dutch)	Baroque	Dutch
LIMBOURG, Pol de fl.1399–1416 (French)	International Gothic	French

POL DE LIMBOURG *The Meeting of the Magi from the Hours of the Duc de Berry* (detail left)

LIPPI *Esther and Ahasuerus* (detail right)

NAME AND NATIONALITY	STYLE	SCHOOL
LIPPI, Filippino c.1457–1504 (Italian)	Renaissance	Florentine
LIPPI, Fra Filippo c.1406–69 (Italian)	Renaissance	Florentine
LISS, Johann c.1595–1629/30 (German)	Baroque	German
LOCHNER, Stefan fl.1442–51 (German)	Renaissance	German
LONGHI, Pietro 1702–85 (Italian)	Rococo	Italian
LORENZETTI, Ambrogio fl.1319–48 (Italian)	International Gothic	Siennese
LORENZETTI, Pietro fl.1320–48 (Italian)	International Gothic	Siennese
LORENZO, Monaco fl.1388–1422 (Italian)	International Gothic	Florentine
LOTTO, Lorenzo c.1480–c.1556 (Italian)	High Renaissance	Venetian
LOUIS, Morris 1912–62 (American)	Abstract Expressionism	—
LUCAS, van Leyden 1494–1533 (Dutch)	High Renaissance	Dutch
LUINI, Bernardino c.1481–1532 (Italian)	High Renaissance	Italian

NAME AND NATIONALITY	STYLE	SCHOOL
M MABUSE, Gossaert Jan c.1478–1532 (Flemish)	High Renaissance	Flemish
MACKE, August 1887–1914 (German)	Expressionism	Blaue Reiter
MAGNASCO, Alessandro 1677–1749 (Italian)	Rococo	Italian
MAGRITTE, René 1898–1967 (Belgian)	Surrealism	—
MANET, Édouard 1832–83 (French)	Impressionism	—
MANFREDI, Bartolommeo 1580–1620/2 (Italian)	Baroque	Italian
MANTEGNA, Andrea 1431–1506 (Italian)	Renaissance High Renaissance	Italian
MARATTA, Carlo 1625–1713 (Italian)	Baroque	Italian
MARC, Franz 1880–1916 (German)	Expressionism	Blaue Reiter
MARINETTI, Filippo Tommasso 1876–1944 (Italian)	Futurism	—
MARQUET, Albert 1875–1947 (French)	Fauvism	—
MARTINI, Simone 1284–1344 (Italian)	International Gothic	Siennese
MASACCIO, Tommasso Giovanni di Mone 1401–28 (Italian)	Renaissance	Florentine
MASOLINO da Panicale c.1383–1447 (Italian)	International Gothic	Florentine
MASSON, André 1896– (French)	Surrealism	—
MASSYS, Quentin 1464/5–1530 (Flemish)	High Renaissance	Flemish
MATISSE, Henri 1869–1954 (French)	Fauvism	—
MATTEO di Giovanni 1435–95 (Italian)	Renaissance	Italian
MAYNO, Juan Bautista 1578–1649 (Spanish)	Baroque	Spanish
MEMLINC, Hans 1430/5–94 (Flemish)	Renaissance	Flemish
MEMMI, Lippo fl.1317–47 (Italian)	Byzantine	Siennese
MENGS, Anton Raffael 1728–79 (German)	Neoclassicism	German
METSU, Gabriel 1629–67 (Dutch)	Baroque	Dutch
METZINGER, Jean 1883–1956 (French)	Cubism	—

MONDRIAN *Composition in red, blue and yellow* (left)

MONET *Impression: sunrise* (detail right)

NAME AND NATIONALITY	STYLE	SCHOOL
MURILLO, Bartolomé 1627–82 (Spanish)	Baroque	Spanish
MYTENS, Daniel c.1590–c.1648 (Dutch)	Baroque	Dutch
N NASH, Paul 1889–1946 (English)	Surrealism	—
NAIVEU, Matthys 1647–c.1721 (Dutch)	Baroque	Dutch
NASMYTH, Alexander 1758–1840 (Scottish)	Portraiture in the Grand Manner	British
NEVINSON, Christopher 1889–1946 (English)	Vorticism (Futurism)	—
NEWMAN, Barnett 1905–70 (American)	Abstract	—
NICHOLSON, Ben 1894–1980 (English)	Abstract	—
NOLDE, Emil 1867–1956 (German)	Expressionism	—
O OLDENBURG, Claes 1929– (American)	Pop Art	—
ORCAGNA, Andrea de Cione c.1308–68 (Italian)	Byzantine	Florentine
ORLEY, Bernart van c.1488–1541 (Flemish)	High Renaissance	Flemish
OSTADE, Adriaen van 1610–84 (Dutch)	Baroque	Dutch
OUDRY, Jean Baptiste 1686–1755 (Dutch)	Baroque	Dutch
OVERBECK, Johann Friedrich 1789–1869 (German)	Nazarene	—
P PACHECO, Francesco 1564–1654 (Spanish)	Baroque	Spanish
PALMA GIOVANNE 1544–1628 (Italian)	Mannerism	Italian
PALMA VECCHIO, Jacopo 1480–1528 (Italian)	High Renaissance	Italian
PALMER, Samuel 1805–81 (English)	Romanticism	English
PANNINI, Giovanni c.1691–1765 (Italian)	Neoclassicism	Italian
PARMIGIANINO, Francesco 1503–40 (Italian)	Mannerism	Italian
PASMORE, Victor 1908– (English)	Abstract	—
PATER, Jean Baptiste 1695–1736 (French)	Rococo	French

NAME AND NATIONALITY	STYLE	SCHOOL
PECHSTEIN, Max 1881–1955 (German)	Expressionism	Die Brücke
PELLEGRINI, Giovanni 1675–1741 (Italian)	Rococo	Italian
PENCZ, Georg c.1500–50 (German)	Mannerism	German
PERUGINO, Pietro c.1445/50–1523 (Italian)	Renaissance	Italian
PFORR, Franz 1788–1812 (German)	Nazarene	—
PIAZZETTA, Giovanni 1683–1754 (Italian)	Rococo	Italian
PICABIA, Francis 1879–1953 (Cuban/Spanish)	Dadaism	—

PICASSO *The three women*
(detail left)

PICASSO *The three dancers*
(detail right)

PICASSO, Pablo 1881–1973 (Spanish)	Cubism	—
PIERO, della Francesca c.1410/20–1492 (Italian)	Renaissance	Florentine
PIERO, di Cosimo c.1462–1521 (Italian)	High Renaissance	Florentine
PINTORICCHIO, Bernadino c,1454–1513 (Italian)	Renaissance	Italian
PISANELLO, Antonio 1395–1455/6 (Italian)	International Gothic	Italian
PISSARRO, Camille 1830–1930 (French)	Impressionism	—
PITTONI, Giovanni 1687–1767 (Italian)	Rococo	Italian
POLLAIUOLO, Antonio c.1432–98 (Italian)	Renaissance	Florentine
POLLAIUOLO, Piero c.1441–96 (Italian)	Renaissance	Florentine
POLLOCK, Jackson 1212–56 (American)	Abstract Expressionism	—
PONTORMO, Jacopo 1494–1556 (Italian)	Mannerism	Italian
PORDENONE, Giovanni 1483–1539 (Italian)	Mannerism	Italian

NAME AND NATIONALITY	STYLE	SCHOOL
POUSSIN, Nicolas 1594–1665 (French)	Classicism	French
POZZO, Andrea 1642–1709 (Italian)	Baroque	Italian
PRETI, Mattia 1613–99 (Italian)	Baroque	Italian
PRIMATICCIO, Francesco 1504–70 (Italian)	Mannerism	Italian
PRUD'HON, Pierre-Paul 1758–1823 (French)	Romanticism	French
PUVIS de Chavannes 1824–98 (French)	Symbolism	—
PYNACKER, Adam 1622–73 (Dutch)	Baroque	Dutch
PYNAS, Jan 1583/4–1631 (Dutch)	Baroque	Dutch
R RAEBURN, Sir Henry 1756–1823 (Scottish)	Portraiture in the Grand Manner	British
RAMSAY, Allan 1713–84 (Scottish)	Portraiture in the Grand Manner	British
RAPHAEL 1483–1520 (Italian)	High Renaissance	Italian
RAUSCHENBERG, Robert 1925– (American)	Pop Art	—
REMBRANDT, Harmensz van Rijn 1609–69 (Dutch)	Baroque	Dutch
RENI, Guido 1575–1642 (Italian)	Baroque	Italian
RENOIR, Pierre Auguste 1841–1919 (French	Impressionism	—
REPIN, Ilya 1844–1930 (Russian)	Realism	Russian
RETHEL, Alfred 1816–59 (German)	Romanticism	German
REYNOLDS, Sir Joshua 1723–92 (English)	Portraiture in the Grand Manner	English
RIBALTA, Francisco 1565–1628 (Spanish)	Baroque	Spanish
RIBERA, José 1591–1652 (Spanish)	Baroque	Spanish
RICCI, Sebastiano 1659–1734 (Italian)	Baroque	Italian
RICHTER, Hans 1888–1976 (German)	Dadaism	—
RIGAUD Y ROS, Hyacinthe 1649–1743 (French)	Baroque	French
RILEY, Bridget 1931– (English)	Op Art	—

NAME AND NATIONALITY	STYLE	SCHOOL
ROBERTI, Ercole de c.1450–96 (Italian)	Renaissance	Italian
ROMANO, Giulio c.1499–1546 (Italian)	Mannerism	Italian
ROMNEY, George 1734–1802 (English)	Portraiture in the Grand Manner	English
RONCALLI, Cristoforo 1552–1626 (Italian)	Mannerism	Italian
ROSA, Salvator 1615–73 (Italian)	Baroque	Italian
ROSENQUIST, James 1933– (American)	Pop Art	—
ROSSELLI, Cosimo 1439–1507 (Italian)	Renaissance	Florentine
ROSSETTI, Dante Gabriel 1828–82 (English)	Pre-Raphaelite	English
ROSSO, Fiorentino 1494–1540 (Italian)	Mannerism	Italian
ROTHKO, Mark 1903–70 (American)	Abstract Expressionism	—
ROTTENHAMMER, Hans I 1564–1625 (German)	Mannerism	German
ROUAULT, Georges 1871–1958 (French)	Fauvism	—
ROUSSEAU, Henri (Le Douanier) 1844–1910 (French)	Symbolism	—
ROUSSEAU, Théodore 1812–67 (French)	Realism	French
ROWLANDSON, Thomas 1756–1827 (English)	Moralism	English
RUBENS, Sir Peter Paul 1577–1640 (Flemish)	Baroque	Flemish
RUISDAEL, Jacob van 1628/9–1682 (Dutch)	Baroque	Dutch
RUSSOLO, Luigi 1885–1947 (Italian)	Futurism	—
RUYSDAEL, Salomon van 1600/2–1670 (Dutch)	Baroque	Dutch
S SACCHI, Andrea 1599–1661 (Italian)	Baroque	Italian
SAENREDAM, Pieter 1597–1665 (Dutch)	Baroque	Dutch
SALVIATI, Francesco 1510–63 (Italian)	Mannerism	Italian
SANDRART, Joachim von 1606–88 (German)	Baroque	German
SARACENI, Carlo 1579–1620 (Italian)	Baroque	Italian

NAME AND NATIONALITY	STYLE	SCHOOL
SARGENT, John Singer 1856–1925 (American)	Neo-Impressionism	—
SAVERY, Roelandt c.1576–1639 (Flemish)	High Renaissance	Flemish
SAVOLDO, Giovanni fl.1505–48 (Italian)	Mannerism	Italian
SCHIELE, Egon 1890–1918 (Austrian)	Expressionism	—
SCHMIDT-ROTTLUFF, Karl 1884–1976 (German)	Expressionism	Die Brücke
SCHONGAUER, Martin 1465–91 (German)	Renaissance	German
SCHWINDT, Moritz von 1804–71 (Austrian)	Romanticism	—
SCHWITTERS, Kurt 1887–1948 (German)	Dadaism	—
SCOREL, Jan van 1495–1562 (Dutch)	High Renaissance	Dutch
SEBASTIANO del Piombo 1485–1547 (Italian)	Mannerism	Venetian
SEGANTINI, Giovanni 1858–99 (Italian)	Neo-Impressionism	—
SEGHERS, Hercules 1589/90–1638 (Dutch)	Baroque	Dutch
SEURAT, Georges 1859–91 (French)	Impressionism	—
SEVERINI, Gino 1883–1966 (Italian)	Futurism	—
SICKERT, Walter 1860–1942 (English)	Impressionism	—
SIGNAC, Paul 1863–1935 (French)	Neo-Impressionism	—
SIGNORELLI, Luca 1441/50–1523 (Italian)	Renaissance	Florentine
SISLEY, Alfred 1839–99 (French)	Impressionism	—
SLEVOGT, Max 1868–1932 (German)	Impressionism	—
SNYDERS, Frans 1579–1657 (French)	Baroque	Flemish
SODOMA, Giovanni 1477–1549 (Italian)	High Renaissance	Italian
SOLIMENA, Francesco 1657–1747 (Italian)	Baroque	Italian
SPITZWEG, Carl 1808–85 (German)	Realism	German
SPRANGER, Bartolomeus 1546–1611 (French)	Mannerism	French

NAME AND NATIONALITY	STYLE	SCHOOL
STANZIONE, Massimo 1585/6–1656 (Italian)	Baroque	Italian
STEEN, Jan 1626–79 (Dutch)	Baroque	Dutch
STRIGEL, Bernhardin 1460/61–1528 (German)	High Renaissance	German
STORCK, Abraham 1635–1710 (Dutch)	Baroque	Dutch
STROZZI, Bernardo 1581–1644 (Italian)	Baroque	Italian
STUBBS, George 1724–1806 (English)	Portraiture in the Grand Manner	English
STELLA, Frank 1936– (American)	Abstract	—
T TANGUY, Yves 1900–55 (French)	Surrealism	—
TENIERS, David I 1582–1649 (Dutch)	Baroque	Dutch
TENIERS, David II 1610–90 (Dutch)	Baroque	Dutch
TER BORCH, Gerard 1617–81 (Dutch)	Baroque	Dutch
TERBRUGGHEN, Hendrick 1588–1629 (Dutch)	Baroque	Dutch
THORNHILL, Sir James 1675/6–1734 (English)	Baroque	English
TIBALDI, Pellegrino 1527–96 (Italian)	Mannerism	Italian
TIEPOLO, Giovanni Battista 1696–1770 (Italian)	Rococo	Venetian
TIEPOLO, Giovanni Domenico 1727–1804 (Italian)	Rococo	Venetian
TINTORETTO, Jacopo 1518–94 (Italian)	Mannerism	Venetian
TITIAN, (Tiziano Vecelli) 1487/90–1576 (Italian)	High Renaissance	Venetian
TOBEY, Mark 1890–1976 (American)	Abstract Expressionism	—
TOULOUSE-LAUTREC, Henri Marie Raymond 1864–1901 (French)	Post-Impressionism	—
TRAINI, Francesco fl.c.1321–45 (Italian)	Medieval	Italian
TROY, Jean François de 1679–1752 (French)	Neo classical	French
TURA, Cosmè c1431–95 (Italian)	Renaissance	Italian

NAME AND NATIONALITY	STYLE	SCHOOL
Turner, Joseph Mallord William 1775–1851 (English)	Romanticism	English
U Uccello, Paolo 1396/7–1475 (Italian)	Renaissance	Florentine
Ugolino da Siena *fl.*1317–27 (Italian)	Medieval	Siennese
Utrillo, Maurice 1883–1955 (French)	Impressionism	—
V Valentin, Moïse Le 1591/4–1632 (French)	Baroque	French
Valtat, Louis 1869–1952 (French)	Fauvism	—
Vasarély, Victor 1908– (French)	Op Art	—
Vasari, Giorgio 1511–74 (Italian)	High Renaissance	Florentine
Velázquez, Diego Rodríguez de Silva 1599–1660 (Spanish)	Baroque	Spanish
Vecchieta 1412–80 (Italian)	Renaissance	Italian
Velde, Adriaen van de 1636–72 (Dutch)	Baroque	Dutch
Velde, Esaias van de 1591–1630 (Dutch)	Baroque	Dutch
Velde, Willem I van de 1611–93 (Dutch)	Baroque	Dutch
Velde, Willem II van de 1633–1707 (Dutch)	Baroque	Dutch
Vermeer, Jan 1632–75 (Dutch)	Baroque	Dutch
Vernet, Claude Joseph 1714–89 (French)	Romanticism	French
Veronese, Paolo 1528–88 (Italian)	Mannerism	Italian
Verrocchio, Andrea del 1435–88 (Italian)	Renaissance	Florentine
Victors, Jan 1620–76 (Dutch)	Baroque	Dutch
Vien, Joseph 1716–1809 (French)	Rococo	French
Vigée-Lébrun, Louise Élisabeth 1755–1842 (French)	Neoclassicism	French
Vivarini, Antonio 1440–1476/84 (Italian)	Renaissance	Venetian
Vlaminck, Maurice 1876–1958 (French)	Fauvism	—

NAME AND NATIONALITY	STYLE	SCHOOL
VLIEGER, Simon de c.1600–53 (Dutch)	Baroque	Dutch
VOS, Cornelis de 1584–1651 (Flemish)	Baroque	—
VOS, Martin de 1531/2–1603 (Flemish)	Mannerism	—
VOUET, Simon 1590–1649 (French)	Baroque	—
VRANCX, Sebastien 1573–1647 (Flemish)	High Renaissance	Flemish
VUILLARD, Édouard 1868–1940 (French)	Post-Impressionism	—
W WALLIS, Henry 1830–1916 (English)	Pre-Raphaelite	English
WARHOL, Andy 1930–89 (American)	Pop Art	—
WATTEAU, Jean Antoine 1684–1721 (French)	Rococo	French
WESSELMAN, Tom 1931– (American)	Pop Art	—
WEYDEN, Roger van der 1399/1400–64 (Flemish)	Renaissance	Flemish
WHISTLER, James Abbott McNeill 1834–1902 (English)	Impressionism	—
WILSON, Richard 1713–82 (English)	Neoclassical Landscapist	—
WITTE, Emmanuel de 1616/18–1692 (Dutch)	Baroque	Dutch
WITTEL, Gaspar van 1653–1736 (Dutch)	Neoclassicism	Dutch
WITZ, Konrad 1400/10–1444/6 (Swiss)	Renaissance	—
WOUWERMAN, Philips 1619–68 (Dutch)	Baroque	Dutch
WTEWAEL, Joachim 1566–1638 (Dutch)	Mannerism	Dutch
WYNANTS, Johannes 1643–84 (Dutch)	Baroque	Dutch
Z ZOFFANY, Johann 1725–1810 (German)	Rococo	German
ZUCCARELLI, Francesco 1702–88 (Italian)	Rococo	Italian
ZUCCARO, Taddeo 1529–66 (Italian)	Mannerism	Italian
ZUCCARO, Federico 1540/3–1609 (Italian)	Mannerism	Italian
ZURBARÁN, Francisco de 1598–1664 (Spanish)	Baroque	Spanish

Index

ACKNOWLEDGEMENTS

We would like to thank the Bridgeman Art Library for kindly granting permission to reproduce the works of art contained in this book.

Alte Pinakothek, Munich 71; Cathedral of St. Bavo, Ghent 36B; Chatsworth House, Derbyshire 80; Christie's London 2, 28, 111, 128, 129T, 132, 135; Collezione Jesu, Milan 133; Collection R. R. Neuberger, New York 143; Courtauld Institute Galleries, University of London 123, 124; Edward James Foundation 140; Galleria Dell'Accademia, Venice 46; Galleria Degli Uffizi, Florence 43T; Grosvenor Estate, London 68B; Henry E. Huntington Library and Art Gallery, San Marino, California 108; Hermitage, Leningrad 129B, 130L, 130BR, Johnny Van Haeften Ltd, London 49, 74; Josef Mensing Gallery, Hamm-Rhynern 115; Le Louvre, Paris 5B, 13, 16, 17, 18, 20T, 20BR, 35, 44, 56, 60, 68T, 72, 92, 93, 106T, 106B, 107, 113, 114T, 135; Mauritshuis, The Hague 82; Musée Condé, Chantilly 21, 26; Musée Des Beaux-Arts, Marseilles 90; Musée Des Beaux-Arts, Nantes 88, 99; Musée Des Beaux-Arts, Rennes 70; Musée D'Orsay, Paris 122; Musée Marmottan, Paris 116; Musée National D'Art Moderne, Paris 136; Musées Royaux Des Beaux-Arts De Belgique, Brussel;s 50; Museo De Arte De Catalunya, Barcelona 84B; Museo Di San Marco, Florence 30B; Museum of Modern Art, New York 143; National Gallery, London 19, 32, 34, 36T, 43B, 55, 57, 61, 98, 103, 111B, 138T; National Gallery of Scotland, Edinburgh 84T, 119 National Gallery of Victoria, Melbourne 96; National Maritime Museum, London 79; Palazzo Ducale, Mantua 30T; Palazzo Medici-Riccardi, Florence 23; Palazzo Reale, Turin 89; Prado, Madrid 6, 27, 47C, 47B, 48C, 52, 62, 63, 67, 69, 85, 100, 101, 102; Private Collections 31, 73, 78,. 81, 87, 97, 114B, 137; Rijksmuseum, Amsterdam 76; Rijksmuseum, Kroller-Muller National Museum, Otterloo 121; Santa Maria Della Vittoria, Rome 64, 65; Stadtische Galerie in Lenbachhaus, Munich 138; Staatliche Gemalde-Galerie, Berlin 51; Staatliche Kunstsammlungen, Dresden 112; Tate Gallery, London 8, 109, 127, 139, 141, 144; Uffizzi Gallery, Florence 14, 20BL, 22, 29, 31T, 54; Vatican Museums and Galleries, Rome 41, 42; Victoria and Albert Museum, London 53, 91; Walker Art Gallery, Liverpool 5T, 15; Wallraf-Richartz Museum, Cologne 38; Wilton House, Wiltshire 45; Wolverhampton Art Gallery, Staffordshire 145.